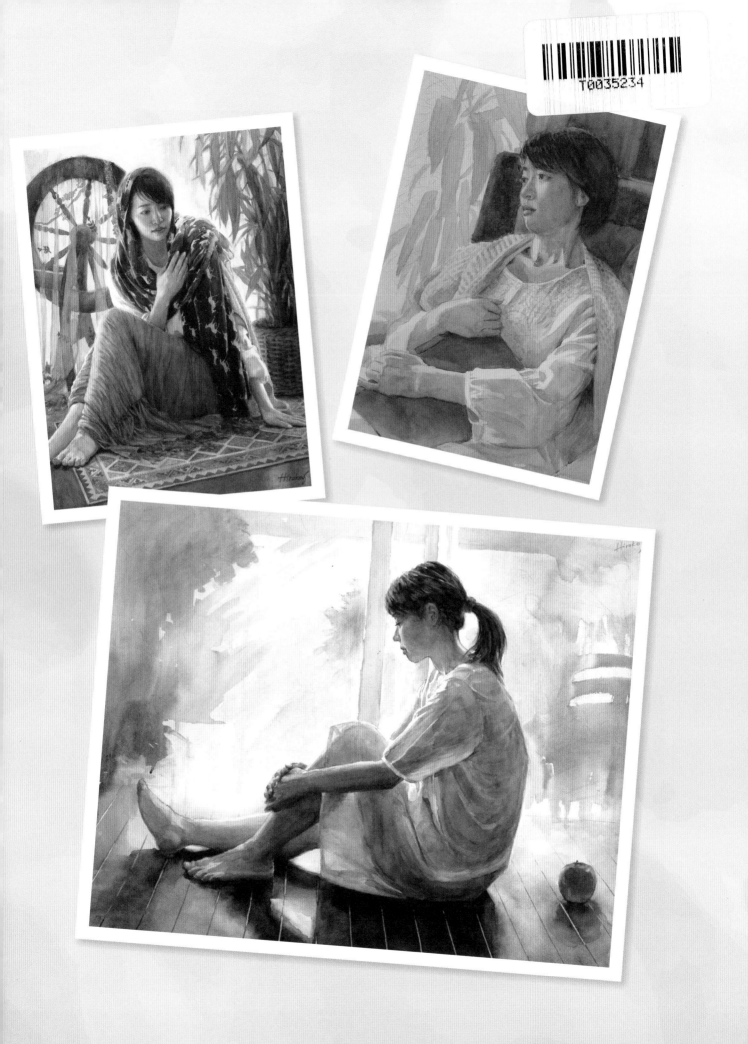

JAPANESE STYLE
WATERCOLOR PORTRAITS

Learn to Paint Lifelike Portraits in 48 Easy Lessons

Hiroko Shibasaki

TUTTLE Publishing

Tokyo | Rutland, Vermont | Singapore

CONTENTS

Why I Wrote This Book

Ever since I first encountered watercolors, I have been mesmerized by the challenge they present compared to other mediums, as well as the new discoveries and surprises I encounter every time I paint with them. This excitement continues to fascinate me. And when it comes to the watercolor portraits that are the subject of this book, the more I explore the subject, the more I discover. As I reflect on my successes and failures, they become invaluable sources of joy that have added so much fulfillment to my life.

People who feel ready to tackle portraits probably already have some familiarity with watercolors. However, once you try to paint a portrait, you may discern that something is off, but you might not be able to put your finger on the problem, or what you can do to improve your work.

In this book, I have compiled some important tips and tricks based on my own experiences. I'm confident that they will be as useful to you as they have been for me.

—**Hiroko Shibasaki**

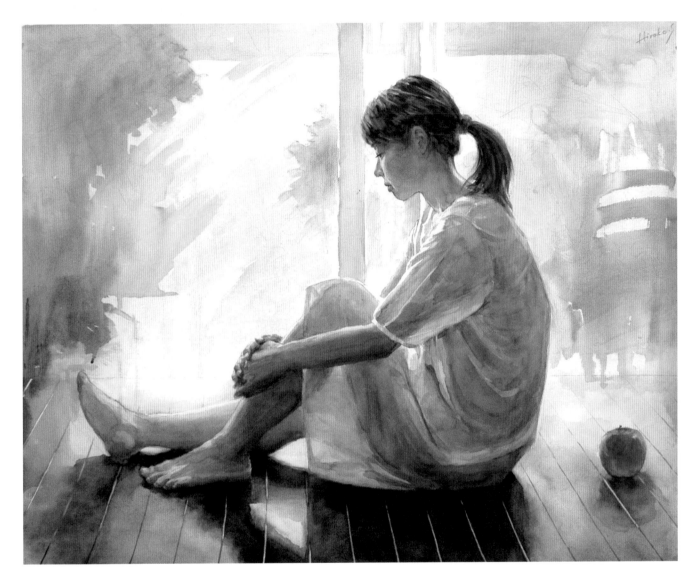

"Beginning in G Minor" F50 (45.7 × 35 in / 116 × 89 cm)

Winner of the Banka Maruyama Award at the 100th Japan Watercolor Exhibition, 2012

A work that depicts the heart of a young woman. The apple is a symbol of the untested potential of the girl's mind.

Paper: Arches

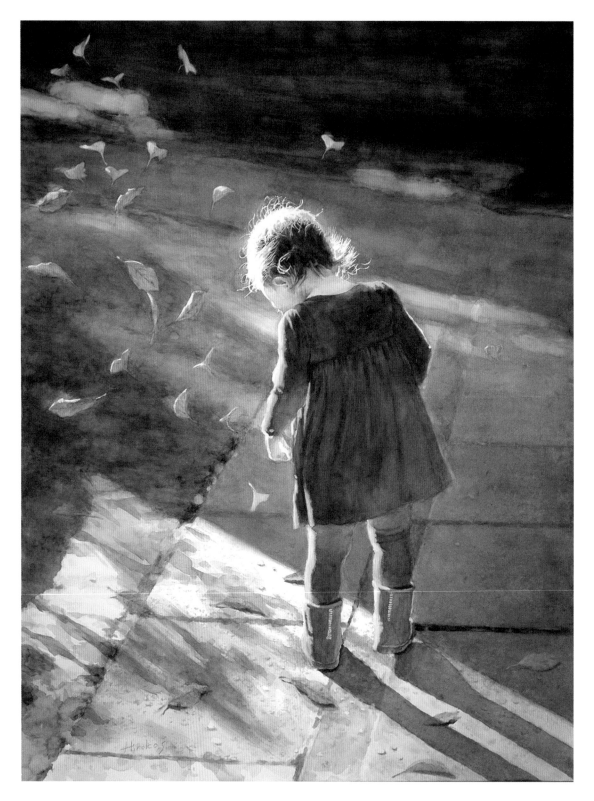

"The Trill of the Wind" F80 (57.4 × 44.9 in / 146 × 114 cm)

Winner of the Association Member's Encouragement Award,
105th Japan Watercolor Exhibition, 2017

Toddlers love shadows, pebbles and fallen leaves. I thought that the gestures of the child who is entranced by these things at her feet was endearing. A trill is produced when adjacent notes on a keyboard are struck in rapid alternation. The falling leaves swirling in the wind are likened to a musical trill.

Paper: Arches

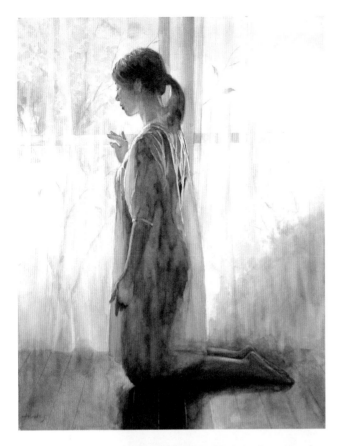

"Early Morning"

F80 (57.4 × 44.9 in / 146 × 114 cm)

Exhibited at the 101st Japan Watercolor Exhibition, 2013

This is a work I did after the 2011 Great East Japan Earthquake. What is beyond the bright window? I wanted to depict the morning light as hope.

Paper: Arches

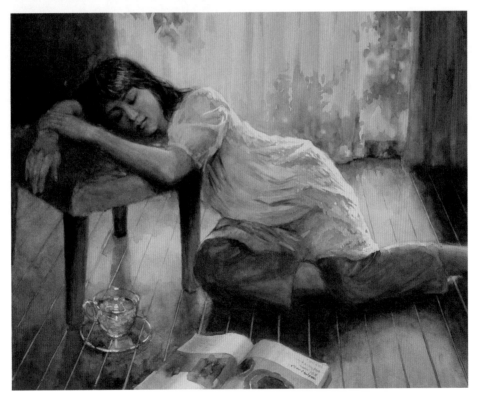

"Summer's End" F40 (39.4 × 31.9 in / 100 × 81 cm)

Winner of the Encouragement Award, 99th Japan Watercolor Exhibition, 2011

I always feel mournful as August nears its end. I wanted to depict that feeling here.

Paper: Arches

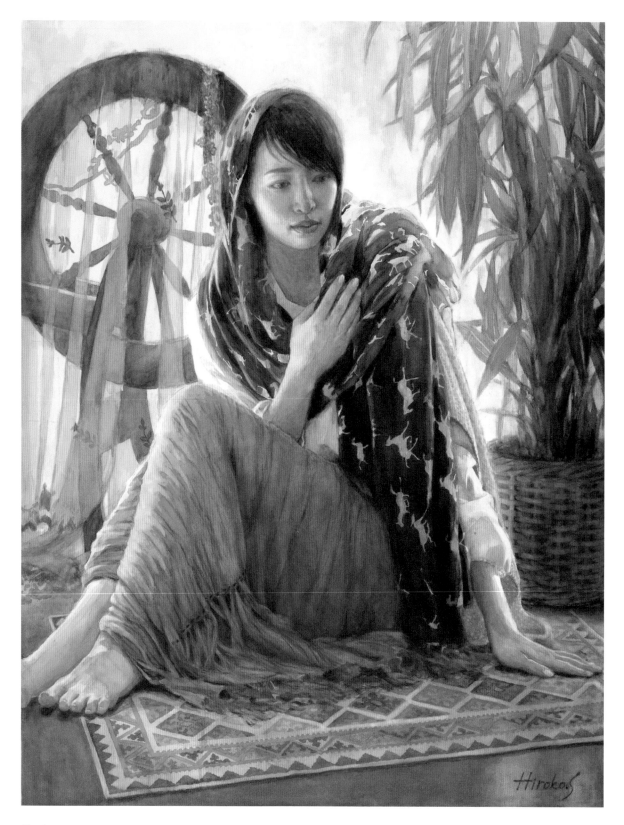

"Pleasant Memories" F80 (57.4 × 44.9 in / 146 × 114 cm)

Winner of the Prime Minister's Award, 107th Japan Watercolor Exhibition, 2019

I wanted to depict the dignified expression of the woman contrasting with the softness of the light and the fabric. The spinning wheel adds depth to the scene as well as leading the eye toward the head of the woman.

Paper: Arches

Chapter 1

Basic Tools, Materials and Techniques

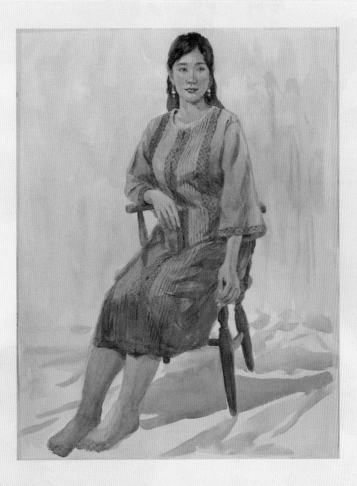

In this chapter, I will introduce you to the materials and basic techniques needed to paint portraits. Choose the materials that you are most comfortable using.

The Tools and Materials Needed for Sketching

Here are some of the basic art materials you'll need.

Lesson 1
Select sketching tools that are convenient and easy to use

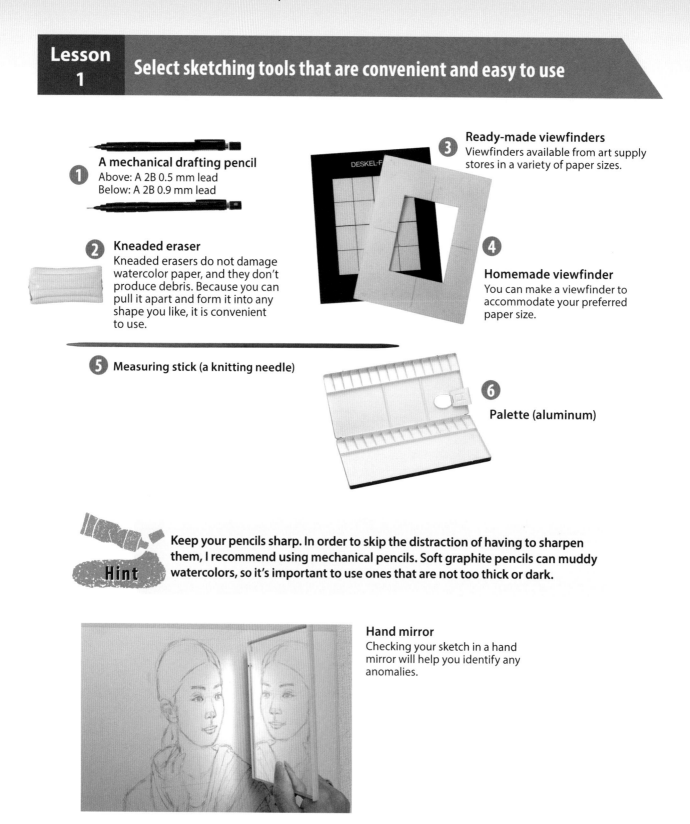

① A mechanical drafting pencil
Above: A 2B 0.5 mm lead
Below: A 2B 0.9 mm lead

② Kneaded eraser
Kneaded erasers do not damage watercolor paper, and they don't produce debris. Because you can pull it apart and form it into any shape you like, it is convenient to use.

③ Ready-made viewfinders
Viewfinders available from art supply stores in a variety of paper sizes.

④ Homemade viewfinder
You can make a viewfinder to accommodate your preferred paper size.

⑤ Measuring stick (a knitting needle)

⑥ Palette (aluminum)

Hint
Keep your pencils sharp. In order to skip the distraction of having to sharpen them, I recommend using mechanical pencils. Soft graphite pencils can muddy watercolors, so it's important to use ones that are not too thick or dark.

Hand mirror
Checking your sketch in a hand mirror will help you identify any anomalies.

The Tools and Materials Needed for Painting

Here, I show you the paints and brushes that I use most often.

Lesson 2 — Use artist's grade transparent watercolors

Artist's-grade watercolors have more pigment than student or amateur-grade ones, so they have a more brilliant color intensity and will not fade easily.

The Holbein watercolor paints shown in the palette above are identified in the chart below.

Ivory Black	Burnt Umber	Burnt Sienna	Raw Umber		Yellow Ochre	Raw Sienna	Crimson Lake	Cadmium Red Deep	Cadmium Red Light	Opera	Cadmium Yellow Orange	Cadmium Yellow Light	Cadmium Yellow Lemon	
△ ×	○ △ ●				○ ●	○ ●	○ ●	○ ● □				○ ●		

Sap Green	Hooker's Green			Ultramarine Light	Cobalt Blue Hue	Cobalt Blue	Cerulean Blue	Manganese Blue Nova
○				○ ● △	○ ●	○ ●	●	● △

The features that I use the color for most often (on its own or mixed)

△···hair
×···eyes
□···lips
○···skin color
●···eyes, shadows

Information from Holbein Artist Materials Co.

Here are the brushes I use most often for painting portraits.

① Kolinsky no. 14

② Kolinsky no. 10

Soft and hold water well. Often used to blend the color of skin or cheeks and more. I use both a large and small brush.

③ Holbein Para Resable no. 10

④ Holbein Para Resable no. 6

Holbein Para Resable brushes are made with a blend of synthetic sable and weasel hairs. Because these two have a lot of body, they are used in situations where visible brush strokes are desired, such as for hair and clothing. I use both a large and small brush.

⑤ Para Resable (flat brush) no. 6
Used to paint straight lines. When turned on its side it can be used to paint straight thin lines too.

⑥ Thin brush no. 1
Used for small details such as the eyes.

① No. 8
Convenient for making large corrections. The back end can be used to scrape off paint.

② No. 0
Used to make detailed corrections.

① Wide bristle brush, 3.35-in (8.5-cm) wide
A brush used in *nihonga*, (Japanese painting). Great for painting large areas.

② Flat bristle brush, 1-in (2.5-cm) wide
A convenient brush for putting down a lot of paint over a wide area, taking advantage of the brush's thickness.

③ Flat bristle brush, 0.8-in (2.0-cm) wide
A brush used in *nihonga*. Since it is soft, it is great for painting over large areas without disturbing the preexisting layer of paint underneath.

Supplemental Tools and Materials to Keep Handy

In addition to the basic tools and materials, here are supplemental resources that are good to have on hand.

Lesson 4 — Get the supplemental tools and materials for great results

1

Pen-type masking fluid (extra thin)

This masking fluid type is good for small details. I have used it in the works "The Trill of the Wind" on page 6 and "Bubbles" on page 111 for the backlit hair.

2

Pen type masking fluid

The usual type of masking fluid pen. It's good for using on areas where you want to leave highlights.

3

Masking fluid, paint-on type

This is a flexible masking fluid.

4 **Brush for masking fluid (I use a cheap no. 0 brush from the dollar store)**

This nylon brush is substantial and easy to use.

5

Masking tape

This is good to use when you do not soak and stretch your paper. To use this, tape all the way around your sheet of paper to secure it.

It is also used to mask straight lines. You can also cut it up to use instead of masking fluid.

6

Hair dryer

Good for when you want to dry your surface quickly.

7

Binder clips

This is an easier way to secure your paper than soaking and stretching it or taping it down with masking tape.

Paper Sizes and Layouts

When you want to paint the whole figure, it's a good idea to choose a large size paper. Small details are difficult to express on small pieces of paper, so zoom in on your subject when using these.

Lesson 5 Understanding which size of paper to use for each type of layout

A guideline to the paper size to use for different types of portraits

Paper size (dimensions)	Used for
F6 (16.14 × 12.51 in / 41 × 31.8 cm)	Upper body
P10 (20.87 × 16.14 in / 53 × 41 cm)	From the head to the knees
P20 (28.62 × 20.87 in / 72.7 × 53 cm)	The whole body or the upper body

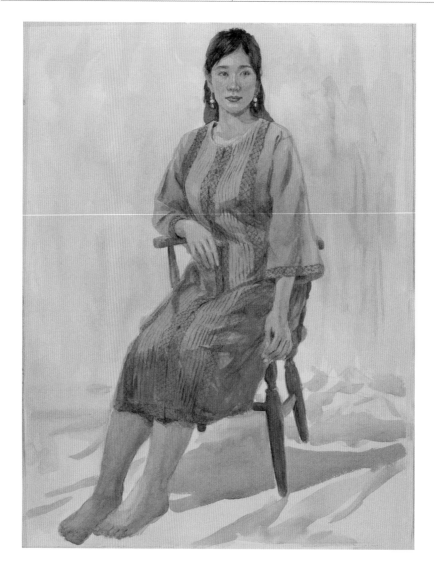

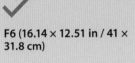

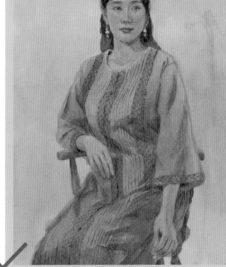

F6 (16.14 × 12.51 in / 41 × 31.8 cm)

P10 (20.87 × 16.14 in / 53 × 41 cm)

It is difficult to express detailed expressions and features on a small piece of paper. I recommend using this as a guide to choosing the right size of paper for the painting you want to do.

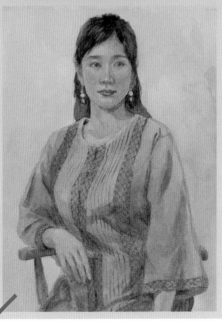

P20 (28.62 × 20.87 in / 72.7 × 53 cm)

Legend
✓ : The appropriate size
⚠ : Not quite the right size
✕ : The wrong size

The Composition Balance Changes Depending on the Angle

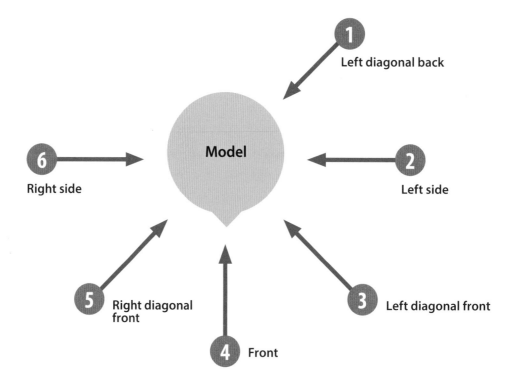

When you view the model from various angles, you will realize that the impression you get changes quite a lot. Don't always paint your subjects from the same angle. Consider the balance of your layout and find the angle that you like.

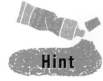

Hint When viewing the model from the side, it's especially important for the body not to lean significantly to one side or the other.

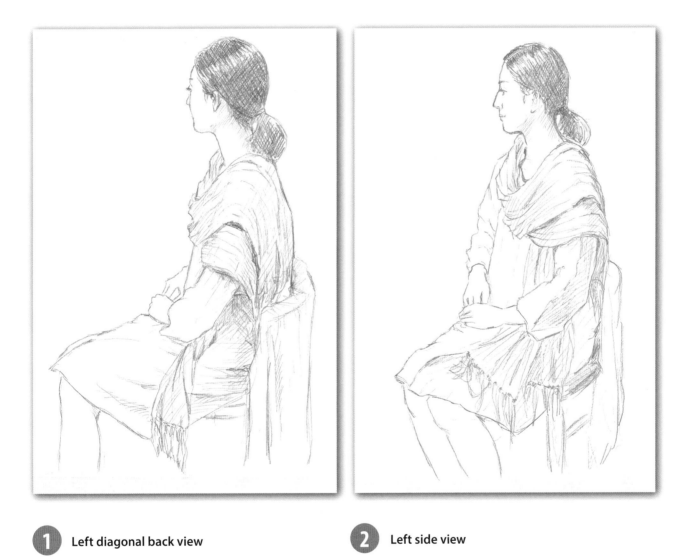

① **Left diagonal back view** **②** **Left side view**

Use these poses when you want to evoke emotions that you can't express when depicting the subject from the front. You need to do something with the background because the direction of the face demands that the space behind the subject be defined.

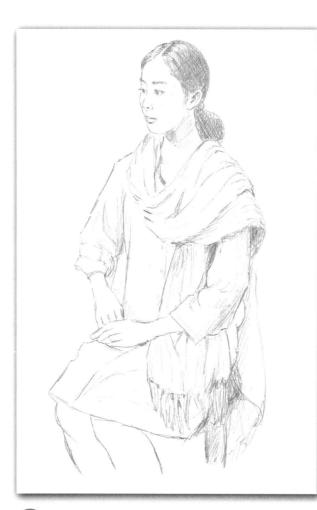

3 Left diagonal front view

An orthodox angle. This angle is easiest to depict for right-handed painters.

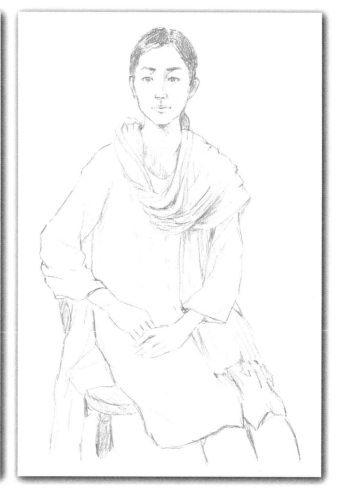

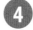

4 Front view

A symmetrical face depicted from a front view has a lot of impact. Use this pose when you want to make a statement.

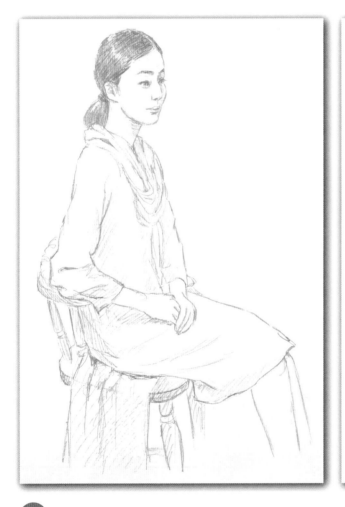

 Right diagonal front view

The expression of the hands is the second most important element after the face. This composition is well balanced.

 Right side view

You can see the model's profile and back in this view. It gives a peaceful impression that speaks to the subject's life and story.

Sidebar

When painting portraits, timely sequential application is important

It's important to keep in mind that when you are working in watercolor, you use a lot of water as well as paint. The reason for this has to do with the interaction of the layers of paint being applied. To put it another way, if you can't layer on paint rapidly, you will not achieve the desired effects.

Paints that are in the process of drying in the palette are not suitable for speedy application in sequence. It's ideal to squeeze the paint out of the tube every time you begin a painting session, but when that's not possible, I gently flood the whole palette, and then turn it over to drain. This softens the surface of the paint and removes the excess water, making it very easy to use. When you are painting at home you can use a spray bottle to wet down your palette, but be careful not to let water pool in the wells. The worst thing you can do is to dip your brush into water every time and attempt to soften the hardened paint that way. If you use this method, areas where you want a large amount of paint may end up being covered too thinly, and it may even damage the brush.

In particular, when you are painting portraits with transparent watercolors, timing and speed are of paramount importance. When you are covering large areas such as background, prepare your paint in advance in quantity on a white plate or in a bowl, so you don't have to add to it as you work.

Chapter 2

Sketching Your Subject

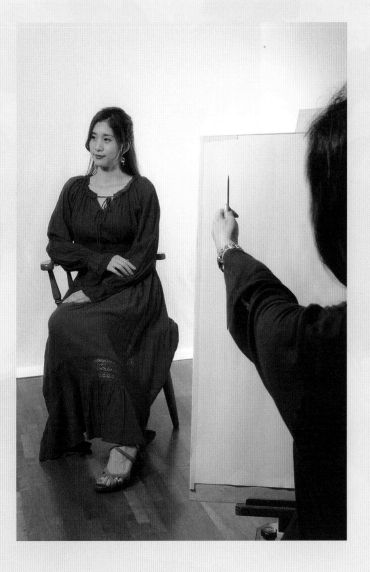

In this chapter, I will show you how to sketch the figure before painting. Once you have created an environment that is conducive to sketching, you are ready to work.

Start By Creating a Good Working Environment

Before you start sketching, place your board at the right height and angle, and make sure the easel is properly situated.

Lesson 7 | **Position your board so you can easily reach the center of the paper**

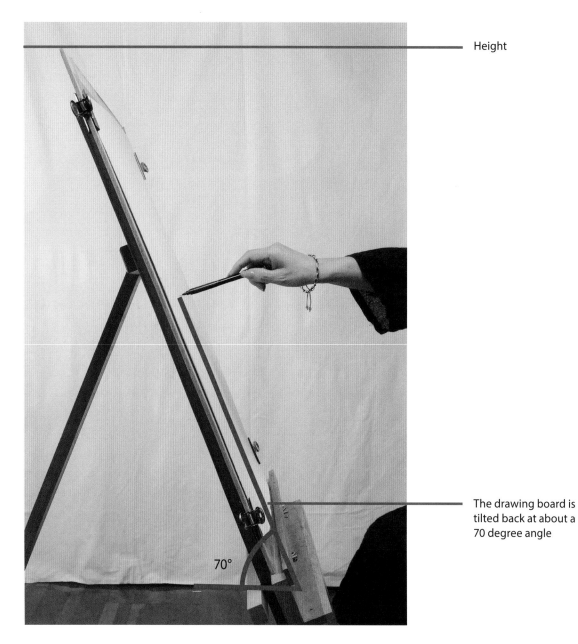

Height

The drawing board is tilted back at about a 70 degree angle

70°

Start by creating an environment that's easy to work in. Adjust the height of the drawing board so that your hand and shoulder do not get tired. Aim to position the board so that when you stretch out your arm, the tip of the pencil makes contact near the middle of the paper.

Lesson 8 Position your easel for optimal model reference

The easel should be positioned so you can see the model just by moving your eyes—not your head.

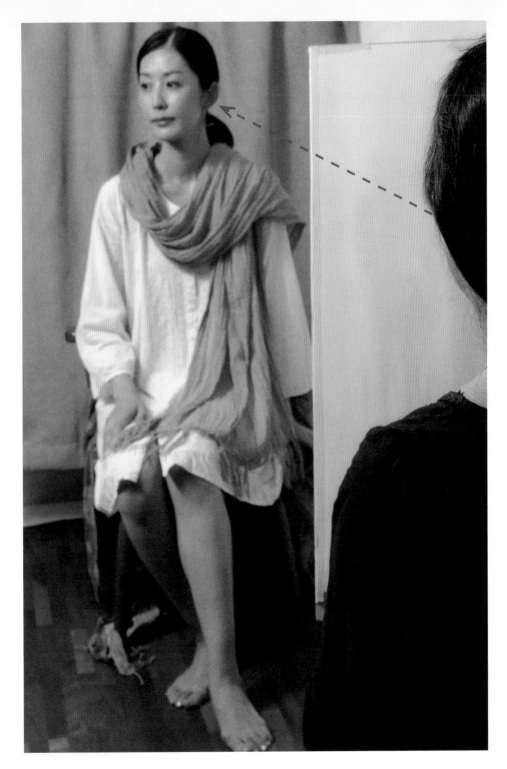

A sketch can go awry when you move your head because in doing so your line of vision shifts quite a bit from left to right. By placing the easel so that it doesn't hide your model, you'll be able to switch rapidly between seeing the model and the paper by just moving your eyes.

Use a measuring stick to determine the proportions of the model

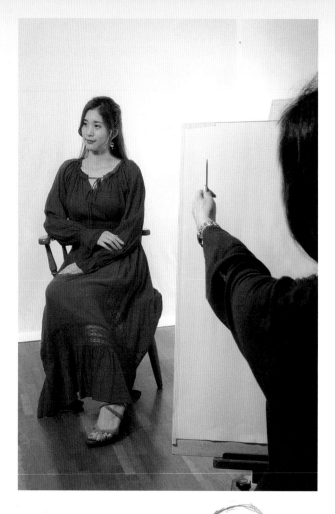

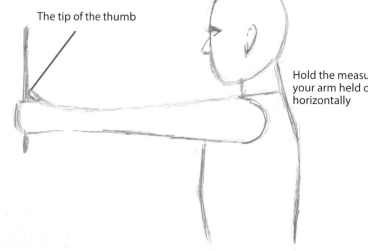

The tip of the thumb

Hold the measuring stick with your arm held out straight horizontally

How to use a measuring stick
Use a measuring stick to check the vertical line, the proportions (of head to body) and tilt. (See pages 30–31 for instructions on how to use a measuring stick.)

Understand the General Flow of the Sketching Process

| Lesson 10 | Understand the sketching process to complete your sketch smoothly |

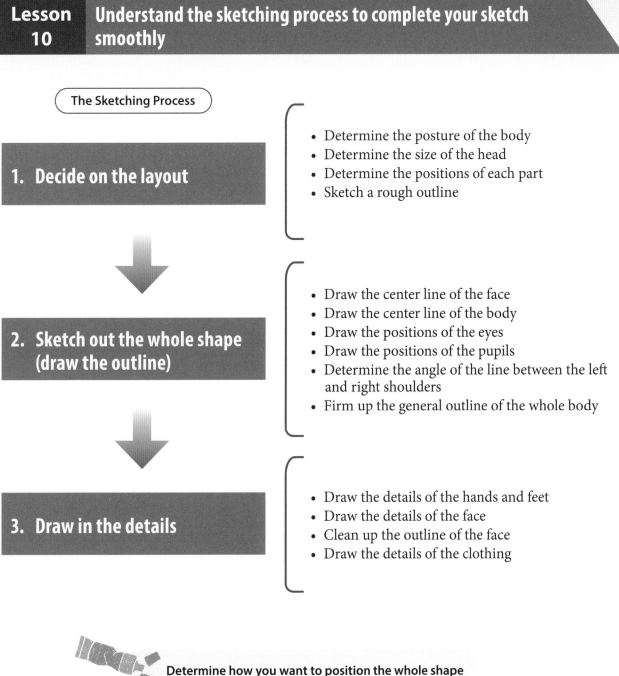

The Sketching Process

1. Decide on the layout

- Determine the posture of the body
- Determine the size of the head
- Determine the positions of each part
- Sketch a rough outline

2. Sketch out the whole shape (draw the outline)

- Draw the center line of the face
- Draw the center line of the body
- Draw the positions of the eyes
- Draw the positions of the pupils
- Determine the angle of the line between the left and right shoulders
- Firm up the general outline of the whole body

3. Draw in the details

- Draw the details of the hands and feet
- Draw the details of the face
- Clean up the outline of the face
- Draw the details of the clothing

Hint Determine how you want to position the whole shape on the paper before you start to sketch!

How to Draw the Details of the Face

Lesson 11 Use the proportions of an average face to understand your model's unique characteristics

People have all kinds of different faces. Below is just an illustration of the proportions of an average face. Determine the positions and shapes of the eyebrows, eyes, nose, ear and so on to capture the unique characteristics of the model.

Before you start to draw, let's look at the most important points when drawing a face.

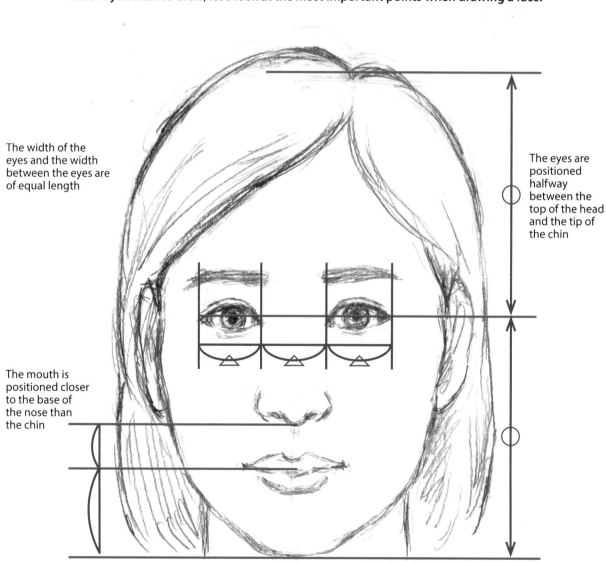

The width of the eyes and the width between the eyes are of equal length

The eyes are positioned halfway between the top of the head and the tip of the chin

The mouth is positioned closer to the base of the nose than the chin

The average proportions of a woman's face

Lesson 12 Similarly scaled faces appear distinct when you change the level of the eyes

If you measured the size of the head, but it still looks too big or too small, perhaps the positions of the eyes differ from those of the model. As illustrated here, the impression one gets can change just by changing the position of the eyes.

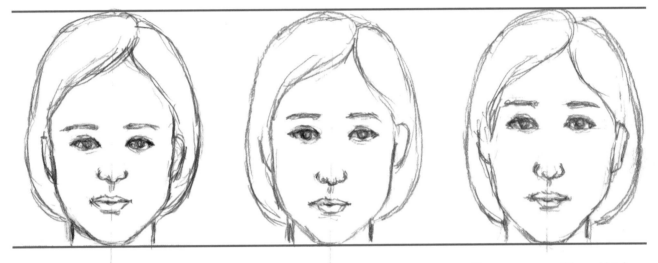

The eyes are positioned low
• Looks childlike
• The face looks small

Average

The eyes are positioned high
• Looks mature
• The face looks big

Hint When you want to depict youthfulness or maturity when painting people, do it with the position of the eyes.

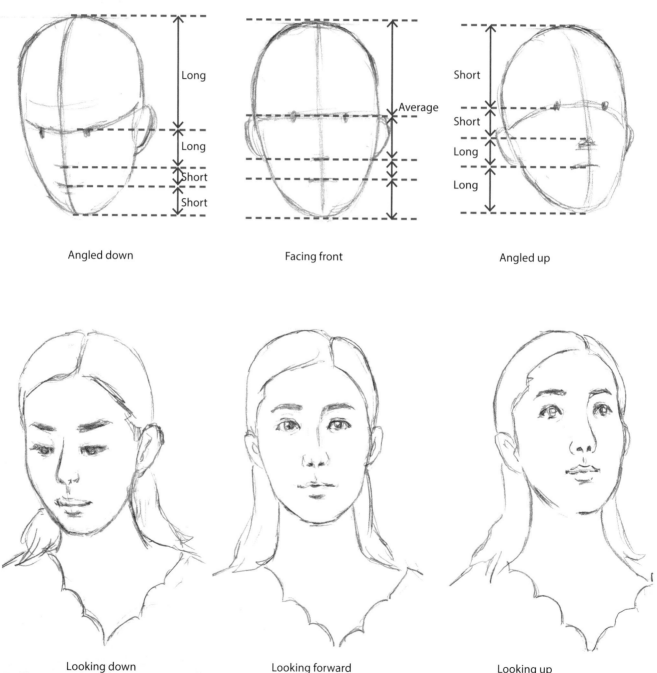

Angled down

Facing front

Angled up

Looking down

Looking forward

Looking up

Lesson 14 — Learn how the shape of the eyes and the look of the eyebrows change depending on the angle

The inner corner of the eye and the inside end of the eyebrow are at approximately the same position along the vertical axis.

The inner end of the eyebrow is to the right of the inner corner of the eye. You can't see the outside corner of the far eye.

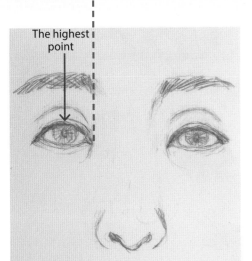

The highest point

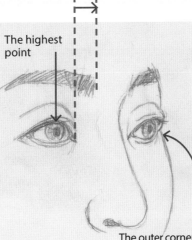

The highest point

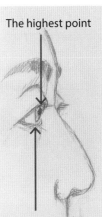

The highest point

The outer corner of the eye is not visible.

You cannot see the inside corner of the eye.

Lesson 15 — See how the shapes of the eyes change depending on where they are looking

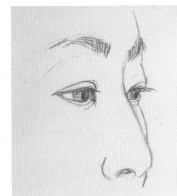

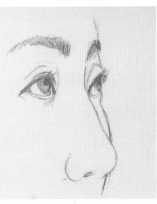

Looking down

Looking forward

Looking up

The eyelids cover the eyeballs and cast a shadow on them.

The eyelids do not cover the eyeballs, so the irises are clearly visible.

The eyelids are pulled up, and you can see the curve of the eyeballs clearly.

Hint

The direction in which the subject is looking plays an important role when depicting people. They can even hugely influence the entire impression the painting gives, so be sure to observe them carefully.

Understanding the Process of Sketching
This section explains the entire process of sketching.

Lesson 16 Use the size of the head as a unit to balance out the figure's proportions

Model

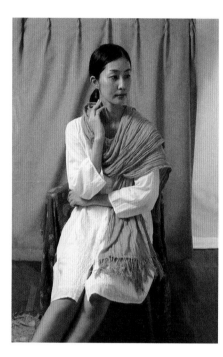

2 Use a measuring stick to measure the length of the head (from the top of the head to the chin). Use this as one unit, and mark that length on the stick.

1 Block in the form. Draw the size of the head, indicate the posture and sketch in the general outline.

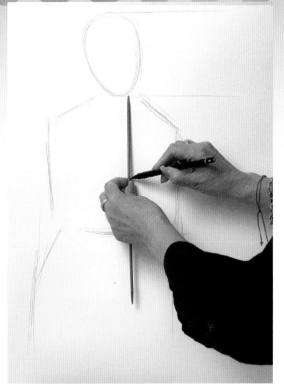

3 Bring the stick down, and mark one head's length down the body of the subject.

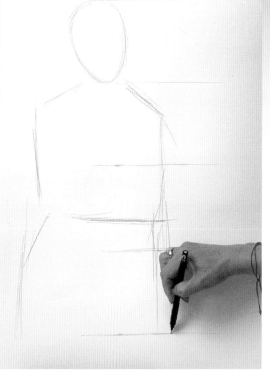

4 Make sure that at least 4 to 5 head length will fit on the paper.

Hint In order to fit your figure's pose in a well balanced way on your paper, using the length of the head is a good solution

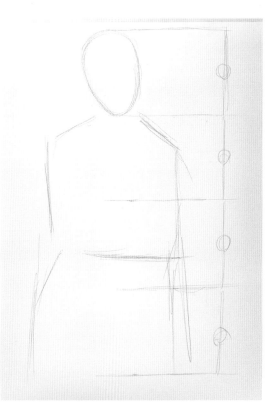

5 This determines the overall proportions.

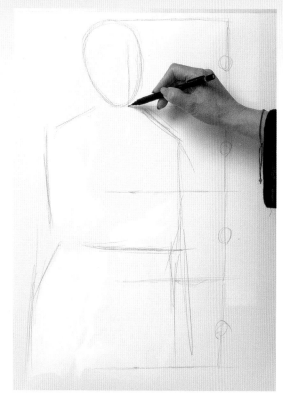

6 Draw in the front center line of the face.

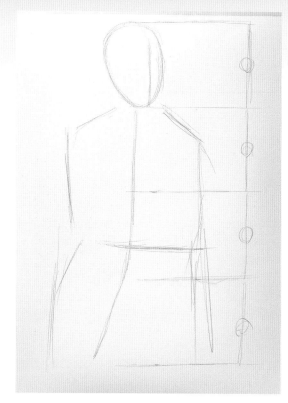

7 Draw in the front center line of the body.

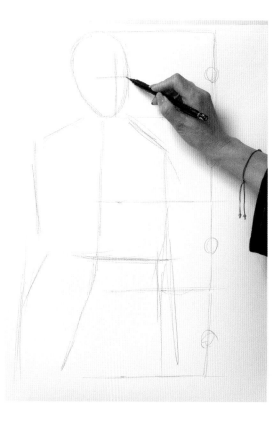

8 Make a line where the eyes should appear.

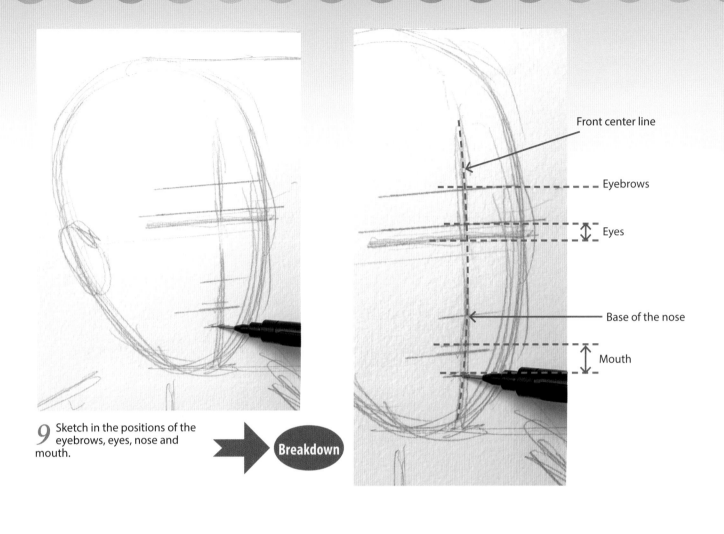

Front center line

Eyebrows

Eyes

Base of the nose

Mouth

9 Sketch in the positions of the eyebrows, eyes, nose and mouth.

Breakdown

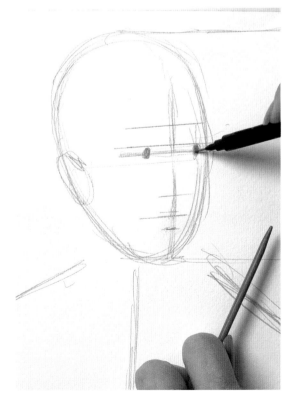

Hint By using the front center line, you can position each feature in a well balanced manner.

10 Draw in the pupils of the eyes.

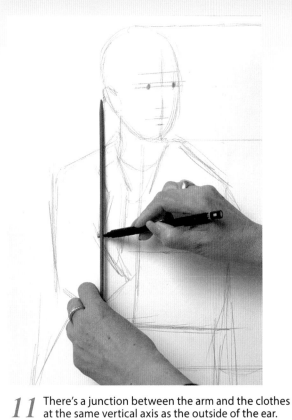

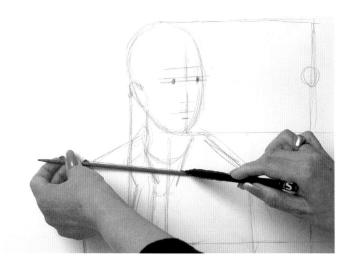

12 Determine the angle of the line between the shoulders with your measuring stick and draw a line.

11 There's a junction between the arm and the clothes at the same vertical axis as the outside of the ear.

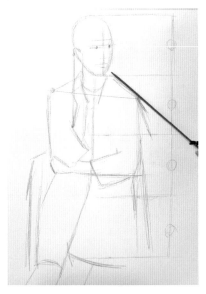

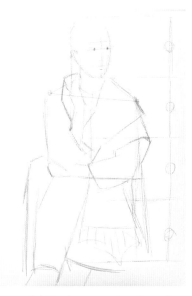

13 Draw the general outline of the chest and torso.

14 Determine the angle of the slope from the shoulder to the neck with your measuring stick and mark that on the paper.

15 Add in the general outline of clothing such as the shawl shown here.

Lesson 19 Clean up the lines of the face and the mouth, and rough in the other features

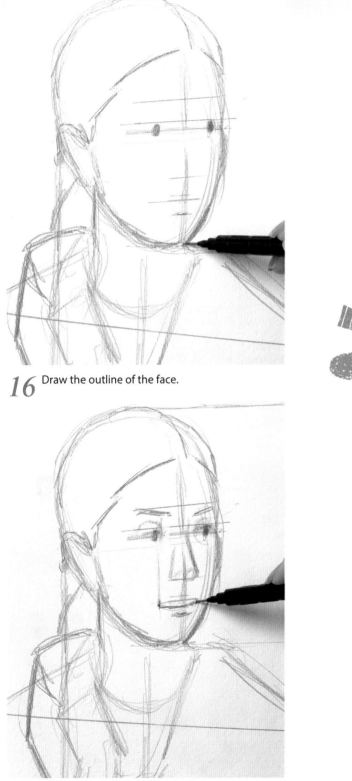

16 Draw the outline of the face.

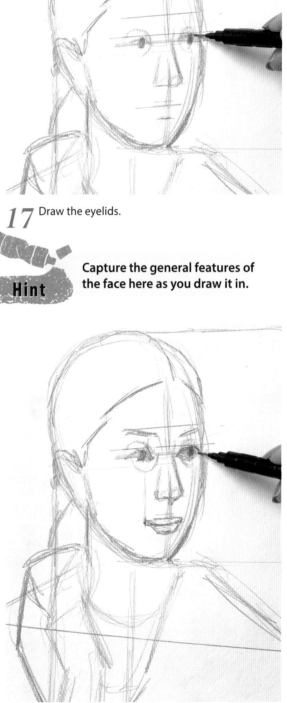

17 Draw the eyelids.

Hint Capture the general features of the face here as you draw it in.

18 Draw the mouth.

19 The eyebrows, eyes, nose and mouth are now sketched in.

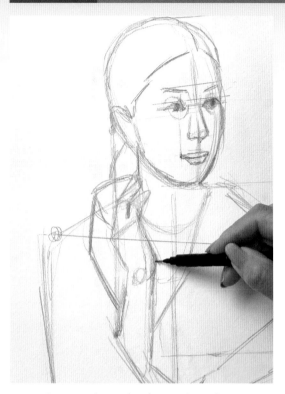

20 Pay attention to the changes in angles as you draw the hand.

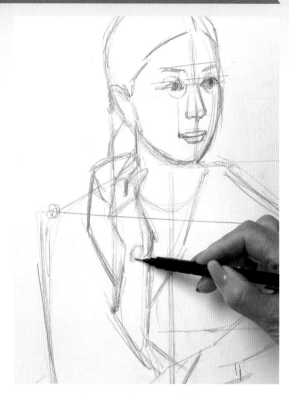

21 Draw the protruding part of the wrist too.

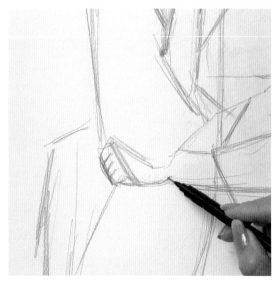

22 Draw the other hand.

Hint At this stage, we have mostly used straight lines for our sketch.

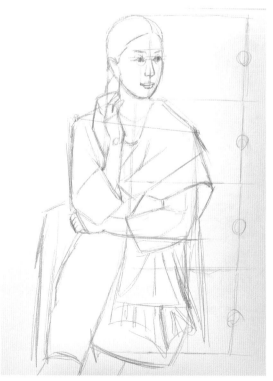

23 The overall sketch is complete.

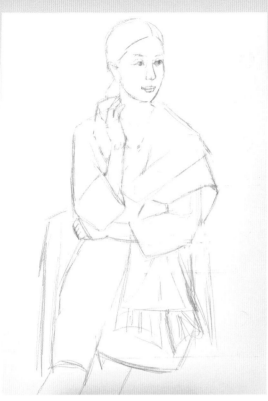

24 Erase the center lines and supplementary lines you made.

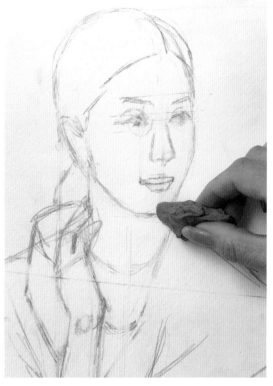

26 Use a kneaded eraser to lighten up the lines that have become too dark.

25 Here, I'm using a 2B 0.9 millimeter lead in my mechanical pencil.

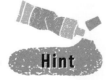

Hint From this point on we will be drawing in the finer details, so we'll be switching to a 2B 0.5 millimeter pencil.

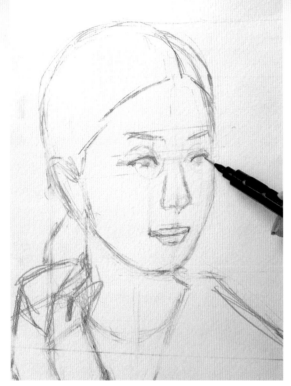

27 Draw the eyes. Start with the eyelids.

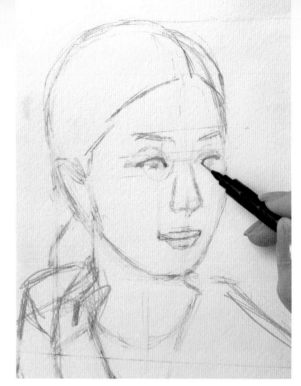

28 Draw the inside corners of the eyes.

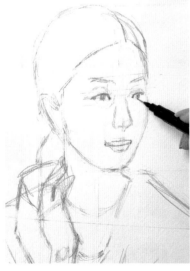

29 Draw the pupils.

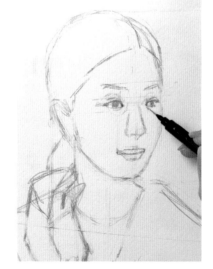

30 Draw the lower eyelids lightly.

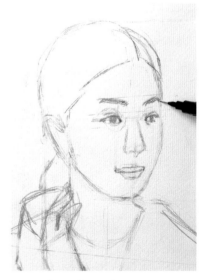

31 Draw the eyebrows.

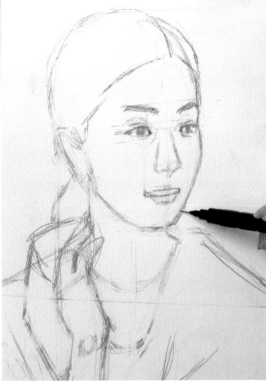

32 Refine the outline of the face.

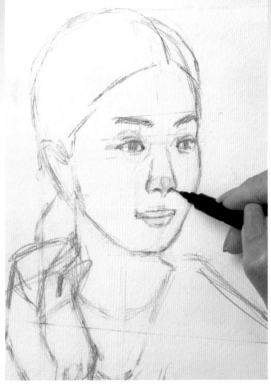

33 Be aware of the three-dimensional structure of the nose as you draw it in.

Breakdown

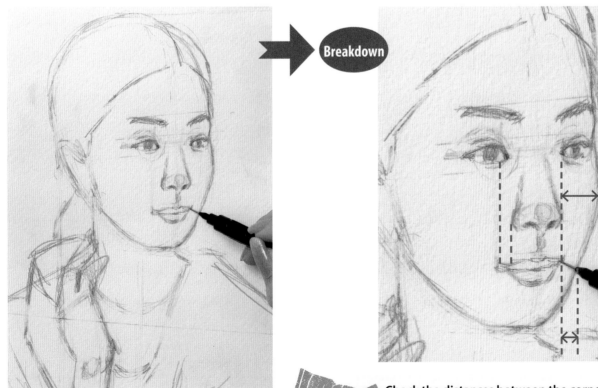

34 Refine the mouth.

Hint Check the distances between the corners of the mouth and the outline of the face. Carefully observe the relationship between the eyes and the base of the nose.

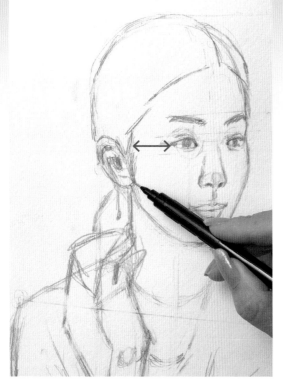

35 Check the distance from the outside corner of the eye as you draw in the ear and the hair in front of the ear.

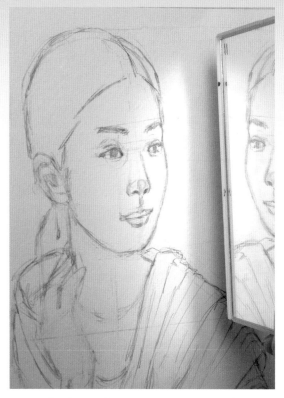

36 Check your drawing in a mirror to see if anything looks off.

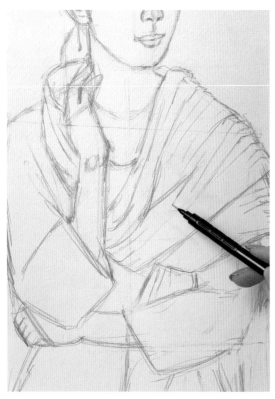

37 Emphasize three-dimensionality all over as you draw in the final details.

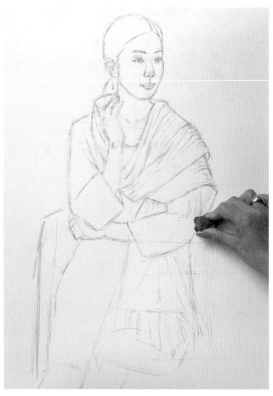

38 Erase any unnecessary lines.

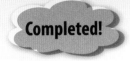

Completed!

The drawing is finished
P20 (28.6 × 20.86 in / 72.7 × 53 cm)
Paper: Arches

Pay attention to the negative spaces

Sketch the figure by not only looking at the shapes of each individual part, but by also determining the shapes that the figure makes in the background or in the gaps (negative space). By making sure you have faithfully indicated these areas, your drawing will be more accurate.

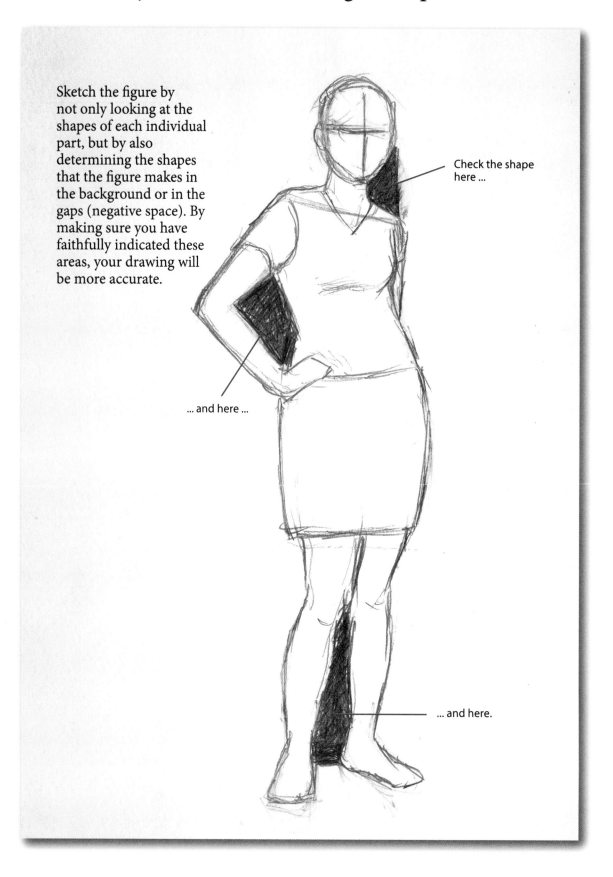

Check the shape here ...

... and here ...

... and here.

Chapter 3

The Painting Process

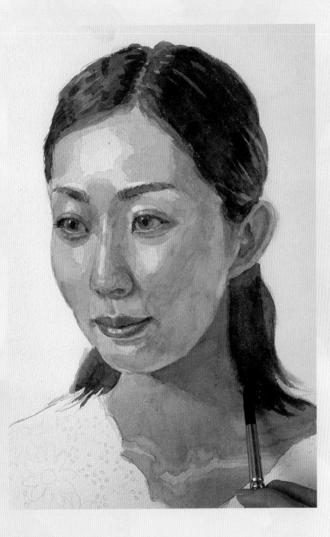

In this chapter, I will give you essential tips for adding color to your painting for a realistic and attractive presentation.

Depicting the Skin and the Shadows

In a figure painting, the skin tone is very important for expressing the vital appearance of the subject. Here, I will show you the key points for how to mix skin colors, and how to apply them.

Lesson 22 — **Mix paint to create the color that matches the model's skin tone**

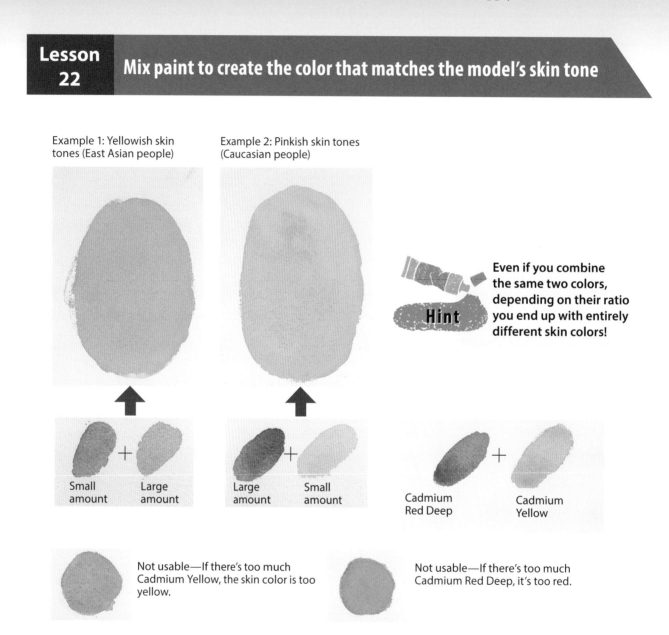

Example 1: Yellowish skin tones (East Asian people)

Example 2: Pinkish skin tones (Caucasian people)

Small amount + Large amount

Large amount + Small amount

Cadmium Red Deep + Cadmium Yellow

Hint — Even if you combine the same two colors, depending on their ratio you end up with entirely different skin colors!

Not usable—If there's too much Cadmium Yellow, the skin color is too yellow.

Not usable—If there's too much Cadmium Red Deep, it's too red.

Everyone has a different skin color. Try your color out on a separate piece of paper before deciding which to use. Besides Cadmium Red Deep + Cadmium Yellow, try using Cadmium Red Light, Yellow Ochre, Raw Umber, Burnt Sienna, Carmine, Raw Sienna and so on to create the right combination for your model's skin tones.

Lesson 23 — Add shadows to the base skin color using the wet on wet method

Manganese Blue Nova—sole secondary color

Cobalt Blue—sole secondary color

Cadmium Red Deep
+
Cobalt Blue
} Blue-mixed (shadow color)

Crimson Lake
+
Cobalt Blue
+
Cadmium Yellow
} Ochre-mixed (shadow color)

By using the wet on wet method, you can expect different color results than from layering paint over dry areas.

Lesson 24 — Avoid layering the base color and oversaturating the tone

✕

Both examples here use base colors of Cadmium Red Deep + Cadmium Yellow

The base color of Cadmium Red Deep + Cadmium Yellow was layered over the same base color.

✓

The shadow color of Crimson Lake + Cobalt Blue was layered over the base color.

Although layering the same base color will deepen the color, it will also increase the saturation and make it brighter, so it's not suitable for depicting shadows.

Lesson 25 — Use a blended gray tone to paint shadows on patterned clothing, etc.

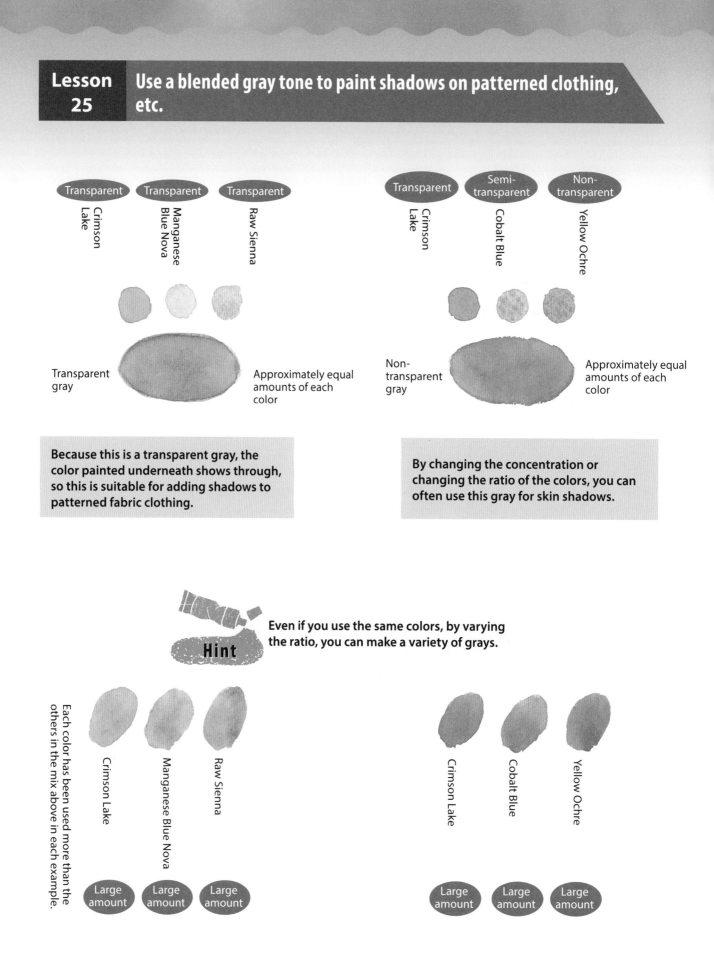

Transparent — Crimson Lake

Transparent — Manganese Blue Nova

Transparent — Raw Sienna

Transparent — Crimson Lake

Semi-transparent — Cobalt Blue

Non-transparent — Yellow Ochre

Transparent gray — Approximately equal amounts of each color

Non-transparent gray — Approximately equal amounts of each color

Because this is a transparent gray, the color painted underneath shows through, so this is suitable for adding shadows to patterned fabric clothing.

By changing the concentration or changing the ratio of the colors, you can often use this gray for skin shadows.

Hint

Even if you use the same colors, by varying the ratio, you can make a variety of grays.

Each color has been used more than the others in the mix above in each example.

Crimson Lake — Large amount

Manganese Blue Nova — Large amount

Raw Sienna — Large amount

Crimson Lake — Large amount

Cobalt Blue — Large amount

Yellow Ochre — Large amount

Lesson 26 Use blended shading when painting the hair and the eyes

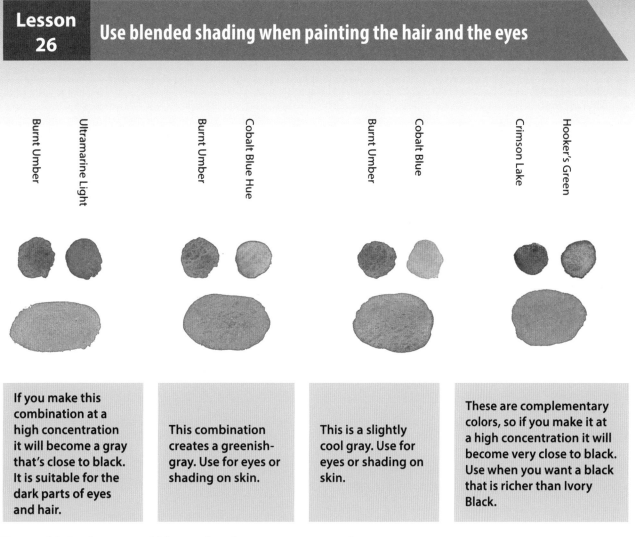

Burnt Umber | Ultramarine Light

Burnt Umber | Cobalt Blue Hue

Burnt Umber | Cobalt Blue

Crimson Lake | Hooker's Green

If you make this combination at a high concentration it will become a gray that's close to black. It is suitable for the dark parts of eyes and hair.

This combination creates a greenish-gray. Use for eyes or shading on skin.

This is a slightly cool gray. Use for eyes or shading on skin.

These are complementary colors, so if you make it at a high concentration it will become very close to black. Use when you want a black that is richer than Ivory Black.

By combining brown and blue, red and green, you can make gray.
Adjust the ratio of each mixed color and try making variations of gray!

An example of a 3-color mix

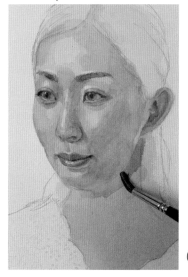

(Page 52)

An example of a 2-color mix

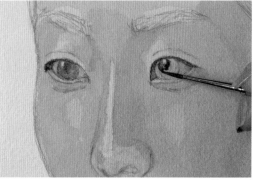

(Page 60)

Painting the Skin

Establish the different types of light and shadow on the face

If you know where the light parts of the face are as well as how the shadows are made and what type they are, you will know which colors to use.

A The planes that face the light source are highlights

B The planes that are angled away from the light source are shaded

C In addition to the primary light source, there is also softer reflected light from the surroundings

D Deep shadows that are created because the area is blocked from the light

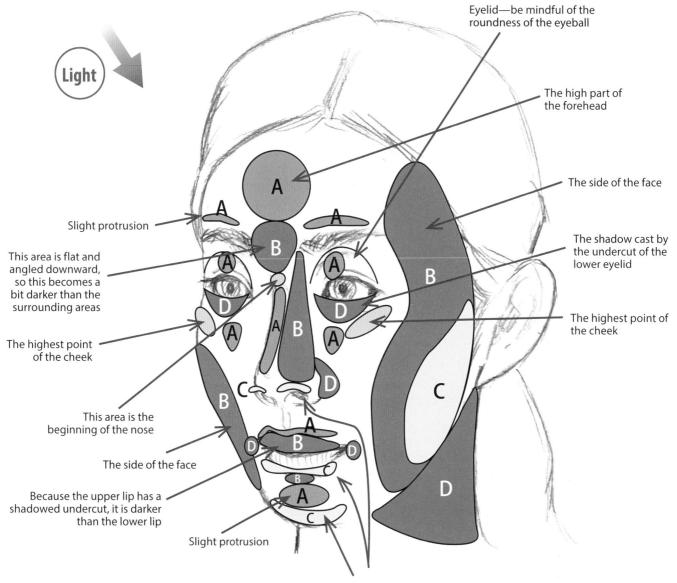

Light

Eyelid—be mindful of the roundness of the eyeball

The high part of the forehead

The side of the face

Slight protrusion

This area is flat and angled downward, so this becomes a bit darker than the surrounding areas

The shadow cast by the undercut of the lower eyelid

The highest point of the cheek

The highest point of the cheek

This area is the beginning of the nose

The side of the face

Because the upper lip has a shadowed undercut, it is darker than the lower lip

Slight protrusion

Reflected light from below

<table>
<tr><td></td></tr>
</table>

Lesson 28	Paint the base color of the skin, including the face

From this point on, I will show you the actual painting process.

Model

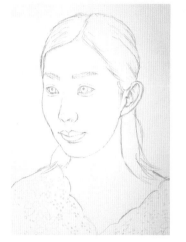

1 Sketch of the face.

2 Do a test swatch of the base skin color (Cadmium Red Deep + Cadmium Yellow) on a separate piece of paper.

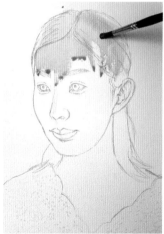

3 Paint the entire head evenly, including the hair.

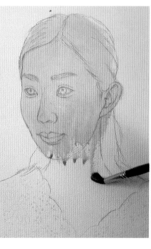

4 Work quickly.

5 Apply the base skin color to all of the hair and the neck as well.

6 Dry with a hair dryer.

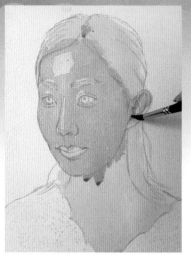

7 Apply another layer of base color to the entire face except for the forehead, the bridge of the nose, the lips, the eyes, the eyelids and the light area above the eyebrows.

8 Apply the second layer from top to bottom, as you did the base layer.

9 Be careful to avoid the places you don't want to paint over, such as the forehead and the bridge of the nose.

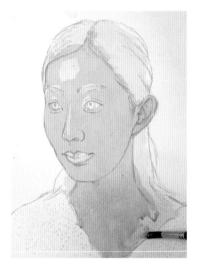

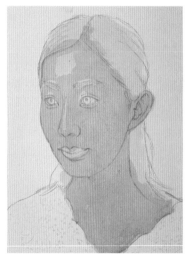

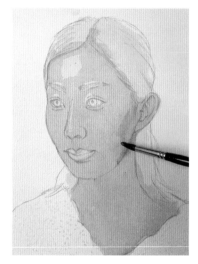

10 Work quickly.

11 Dry at this stage.

12 Add shading on the cheek that has reflected light using Manganese Blue Nova.

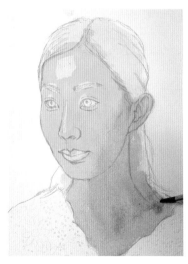

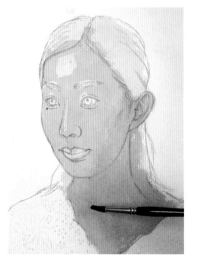

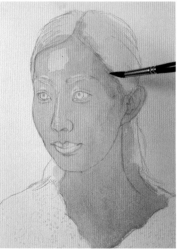

13 Apply Cobalt Blue to the neck to deepen the shadows.

14 Spread and blend.

15 Apply Cobalt Blue to the shadows along the hairline too.

 Hint Use the color differences between Manganese Blue Nova and Cobalt Blue to depict the different depths of the shadows.

Lesson 29 | Layer the paint to achieve more depth in the shadows

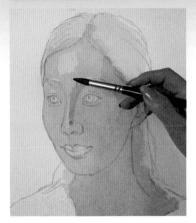

16 Apply Cobalt Blue from the eyebrows down the side of the nose.

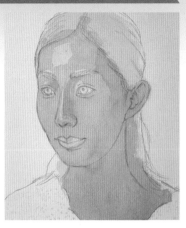

17 Apply Cobalt Blue to the chin too.

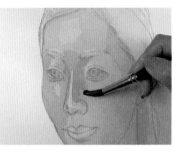

18 Blend the areas with overly sharp borders.

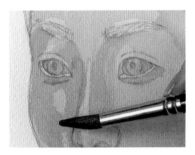

19 Deepen the shadows more with a third layer. The shadows on the face use the following colors: Crimson lake (a large amount) + Cobalt Blue (a medium amount) + Yellow Ochre (a large amount).

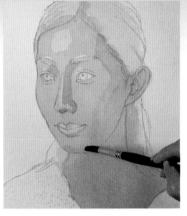

20

Hint

The area between the eyebrows is concave, so put shading there.

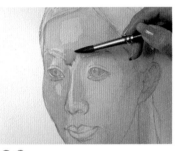

21 Paint in the shadow color on the side of the nose.

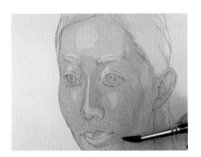

22 Adjust the shadows of the cheeks.

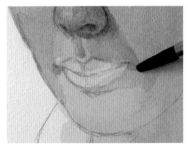

23 Use the shadow color (Crimson Lake + Cobalt Blue [a large amount] + Yellow Ochre) to add shadows, and then blend the edges.

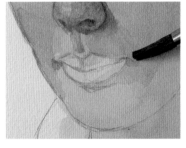

24 Blend the edges.

25 Add shadow color to the chin area, using Cadmium Red Deep + Cobalt Blue.

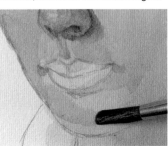

26 Blend the edges.

※ For details on how to paint each part of the face, see page 58.

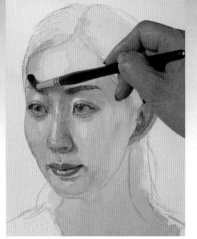

27 Make the forehead look more three-dimensional with Cadmium Red Deep + Yellow Ochre.

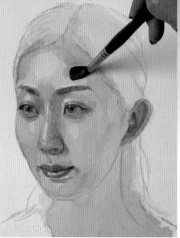

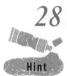

Hint

28 **Be sure to avoid painting the area above the eyebrows where the light hits!**

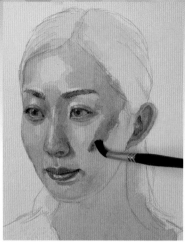

29 Put a large shadow on the side of the face.

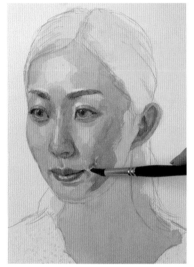

30 Spread it out and blend.

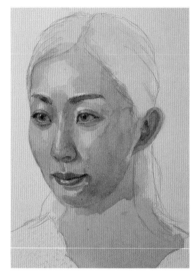

31 Apply shading to the neck.

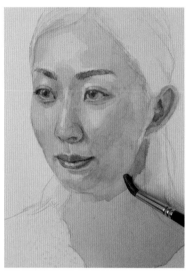

32 Add darker color to the neck (Crimson Lake [a large amount] + Cobalt Blue [a medium amount] + Yellow Ochre [a large amount]).

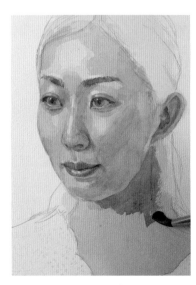

33 Use Crimson Lake + Ultramarine Light + Yellow Ochre to add even deeper shadows.

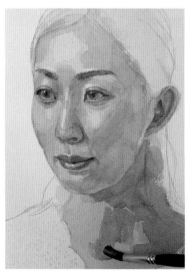

34 Spread out and blend.

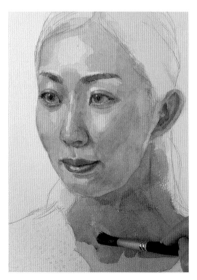

35 Blend to the top of the collarbone.

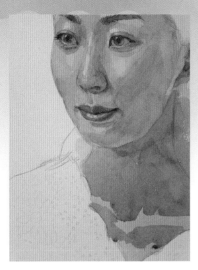

36 Add more deep shadows with a Crimson Lake + Ultramarine Light + Yellow Ochre mix.

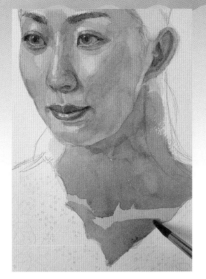

37 Leave the light parts of the collarbone area unpainted.

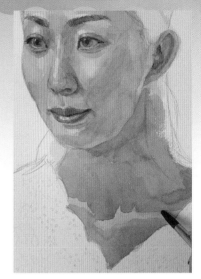

38 Blend the edges.

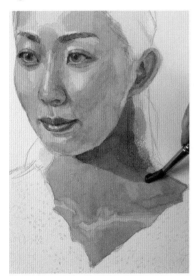

39 Apply Crimson Lake + Ultramarine Light + Burnt Umber.

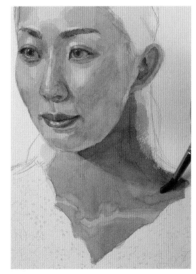

40 Blend.

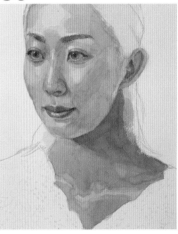

41 Evaluate the entire painting. Ensure that it looks three-dimensional.

By expressing the lights and darks clearly through color, you can depict three dimensionality.

Hint

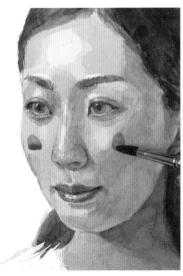

42 I decided that some parts lacked color after observing the whole painting, so I am applying red to the cheeks.

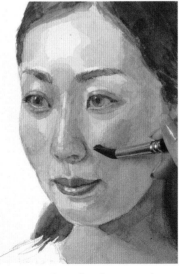

43 Put lots of Cadmium Red Deep on the cheeks, and then spread and blend.

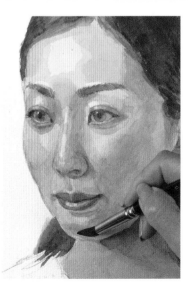

44 Apply some red to the chin part too.

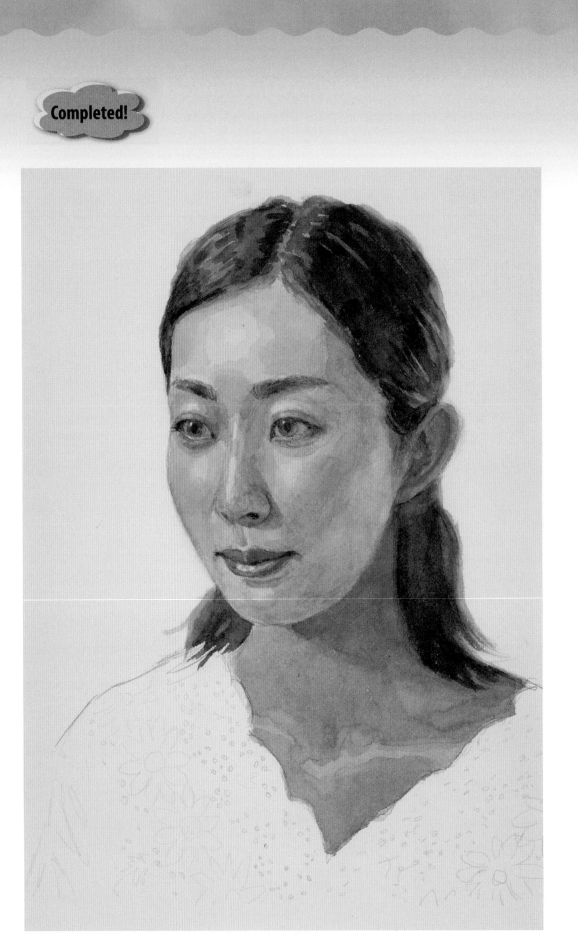

By understanding the process of painting the light parts of the face and how the shadows are created as described on page 48, you can depict the skin very realistically.

Depicting the Hair

Color and three-dimensionality are important for depicting the hair. Let's discuss the important points for bringing out the three-dimensionality of the hair.

| Lesson 30 | Leave the highlights of the hair unpainted as you add the dark colors |

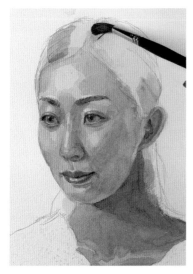

1 Apply blue (Manganese Blue Nova) around the shiny areas of the hair.

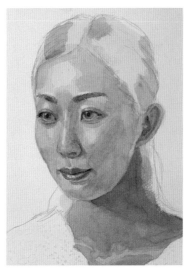

2 The light blue has been applied.

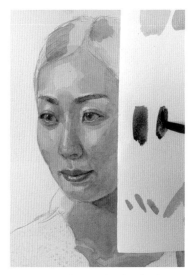

3 Test the base color for the hair (Burnt Umber + Ultramarine Light) on a separate piece of paper.

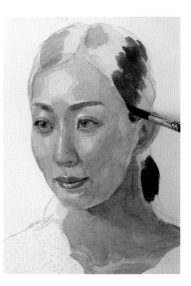

4 Paint on sections of the base color. On the lighter areas, use a mix of Burnt Umber (a larger amount) + Ultramarine Light (a lesser amount).

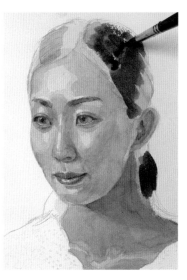

5 In the darker areas, use a mix of Burnt Umber (a medium amount) + Ultramarine Light (a larger amount).

Hint Adjust the amounts of each paint color you use in the mix subtly to bring out the highlights and shadows in the hair.

55

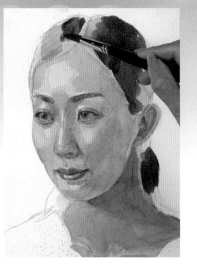

6 Paint the lighter base color mix on the top of the head.

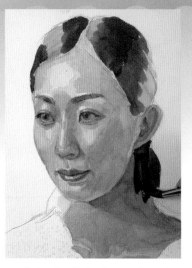

7 Paint the darker base color mix on the part of the hair that's by the neck.

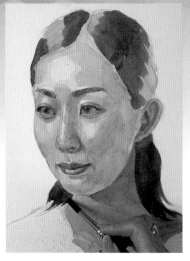

8 Apply lighter base color.

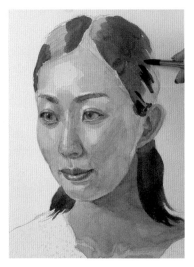

9 Leave the highlights of the hair untouched, and paint in the dark parts.

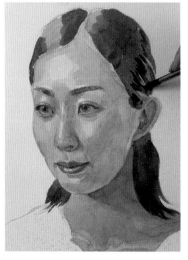

10 Paint in the texture of the hair.

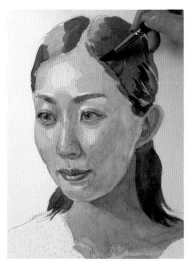

11 Blur the hairline.

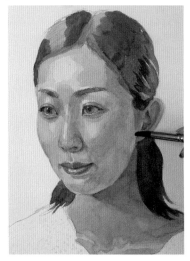

12 Dilute the dark base color mix to paint the hair by the ear, and blend.

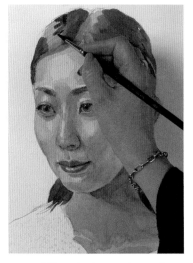

13 Dilute the base color and paint it on the highlights of the hair.

14 Paint the dark base color in the dark parts of the hairline.

Hint **By capturing the light shiny parts of the hair in detail, you can depict the hair's three-dimensionality better.**

15 Layer color onto the dark area of the hair's part.

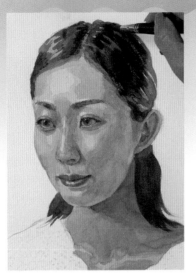

16 Layer the color on the dark parts of the side.

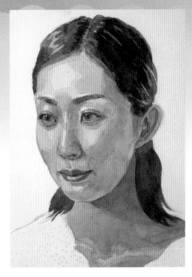

17 At this point the highlights are too bright.

 Hint Emphasize the three-dimensionality by layering the color.

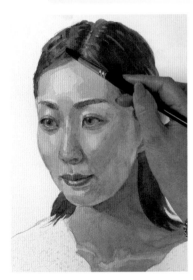

18 Dilute the base color, and adjust the highlights of the hair.

 Completed!

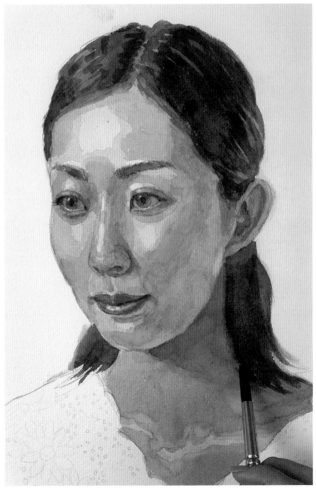

By paying attention to the lightness of the highlights, the hairline, the flow of the hair and so on, you can depict the hair in the lifelike manner.

Depicting Each Part of the Face

Here, I'll show you some tips for depicting each part of the face in a realistic manner.

Lesson 31	When working out the highlights and shadows, simplify the shape of the object

The nose becomes easier to understand if you think of it as a trapezoidal prism.

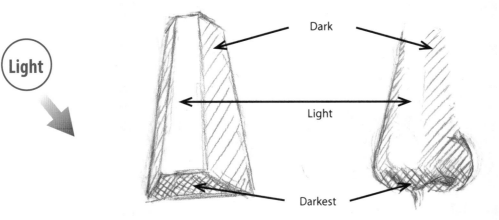

Nose

When considering how the shadows are created, for example if the light source is diagonally above as in the illustration, the side that is opposite from that light will have rather dark shadows, and the area around the nostrils will be darkest.

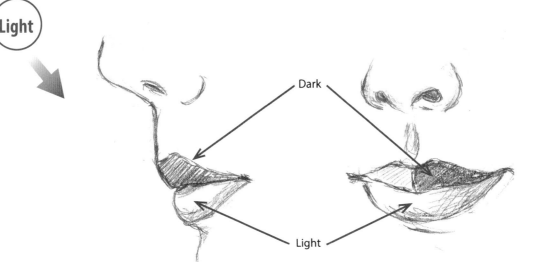

Mouth

When the light source is from above, the lower lip catches the light and is bright, and shadows form on the upper lip. Depending on the angle of the light, a shadow may also be formed on one side of the upper lip, starting from the middle.

Lesson 32 — Add shadows to the eyes and eyelids to depict three-dimensionality

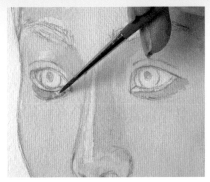

1 Paint in the shadows of the lower eyelids (Crimson Lake + Cobalt Blue + Yellow Ochre)

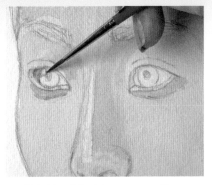

2 Paint in a blueish-gray over the entire eyeball, including the whites. Leave the highlight unpainted however.

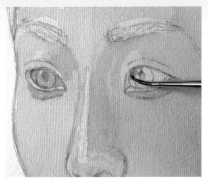

3 Leave the highlight of the opposing eye unpainted too.

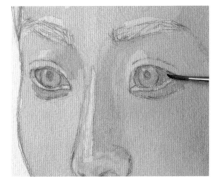

4 Spread the gray out over the entire eyeball.

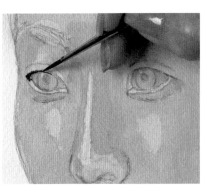

5 Use Burnt Umber + Ultramarine Light for the line of the upper eyelid.

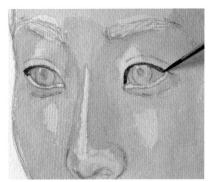

6 Preserve the shape of the curve carefully as you paint it in.

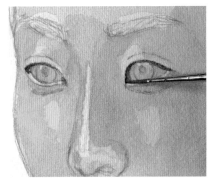

7 Use Cadmium Red Deep + Burnt Umber for the relatively wide inner part of the eyelid.

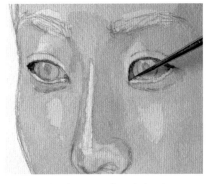

8 Use the thin no. 1 brush for this detail.

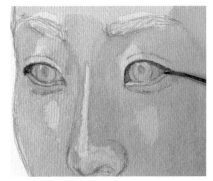

9 Apply some red to the thick part of the lower eyelid. Apply some red to the edge too to emphasize the roundness of the eyeball.

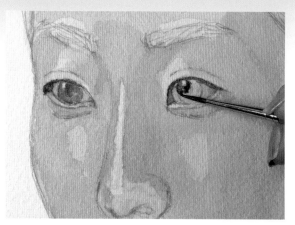

10 Use Burnt Umber + Ultramarine Light to paint in the pupils.

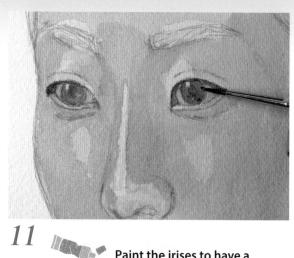

11 Hint **Paint the irises to have a transparent look.**

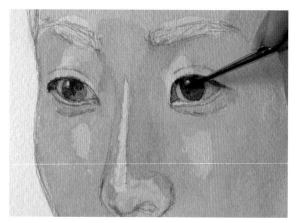

12 Darken the upper part of the pupil.

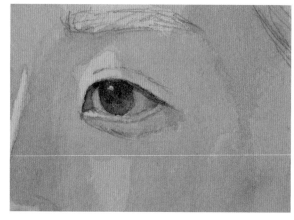

13 Note the sense of transparency and the roundness of the eyeball that's been created.

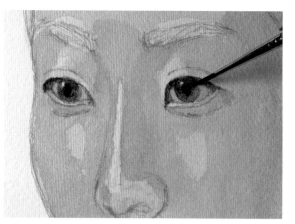

14 Use Ivory Black to establish the positions of the centers of the pupils of both eyes.

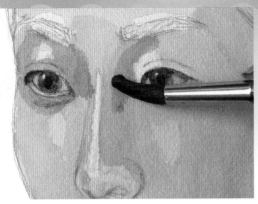

15 Apply the shadow color (Crimson Lake + Cobalt Blue + Yellow Ochre) to depict the three-dimensionality of the eyelids.

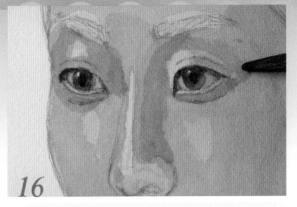

16

Hint By leaving the swell of the eyelids unpainted, you can express their three-dimensionality.

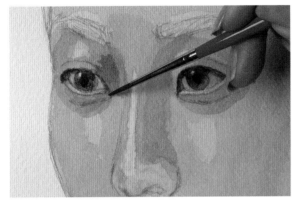

17 Emphasize the three-dimensionality even more.

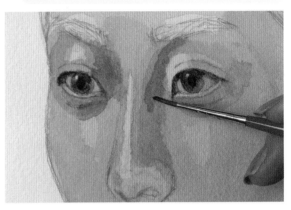

18 Balance out the shading on the left and right sides.

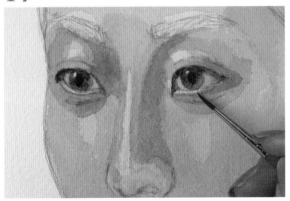

19 The thick part of the lower eyelid is too light here, so apply color for shading.

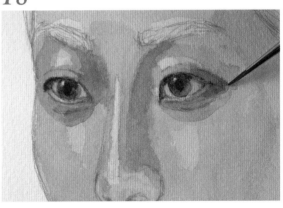

20 Add more shadows along the rim of the eye in a three-dimensional way.

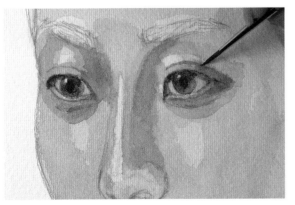

21 Paint the fold of the eyelid with a light shadow color.

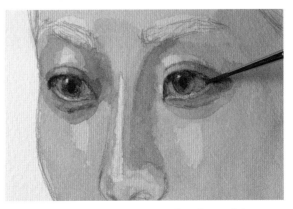

22 If, after adding the shading, the whites of the eyes look too bright, tone them down with a layer of light gray.

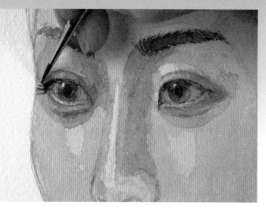

23 Use a thin no. 1 brush to paint the eyelashes.

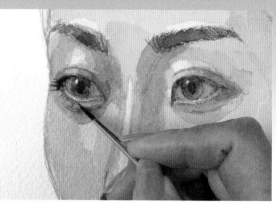

24 Paint the lower lashes too.

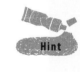 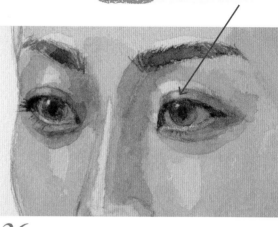

Make this light

Hint

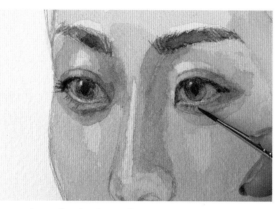 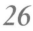

25 Paint the thin lines of the eyelashes by holding the brush straight up.

26

Hint

The eyelid is also shiny above the fold, so wet this area with a thin no. 1 brush and wipe off with a piece of tissue paper to lighten it.

Completed!

The entire painting

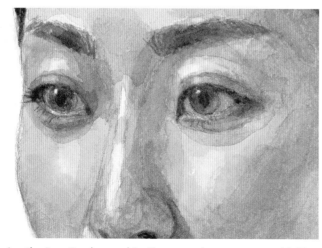

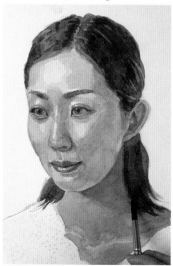

By using the 3- or 2-color combination grays shown on pages 46-47, and leaving the highlight unpainted, you can depict eyeballs with a sense of transparency.

Lesson 34 Paint the eyebrows following the flow of the hair growth

The eyebrows determine the entire expression of the face. Draw this part with care too.

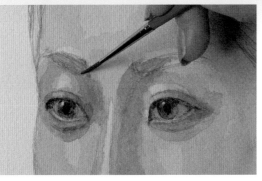

1 Lightly paint in a shadow color over the entire eyebrow.

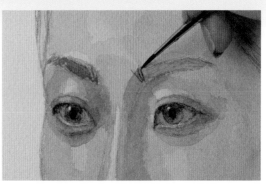

2 Using a thin no. 1 brush, paint in the eyebrows following the growing direction of the hair.

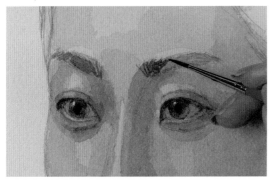

3 The hair grows diagonally upwards around the inner ends of the eyebrows.

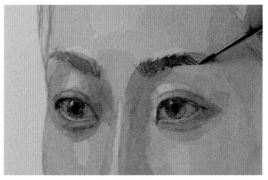

4 Towards the outer ends of the eyebrows the hair grows more diagonally downwards.

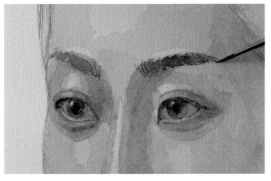

5 Pay attention to the shape of the outer end of the eyebrow.

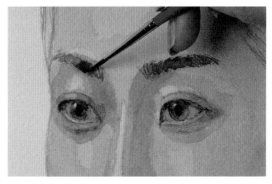

6 Paint the especially dark parts of the eyebrows with more color.

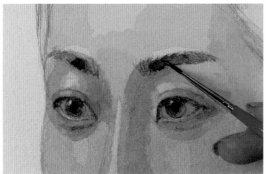

7 Pay attention to the left-right balance.

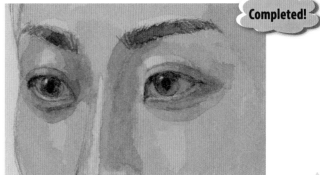

Completed!

When painting the ears, remember to add the shadows cast by the hair around them

Unlike the eyes and eyebrows, the ears don't directly impact the facial expression, but if painted skillfully they give the portrait a realistic look.

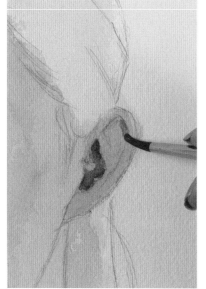

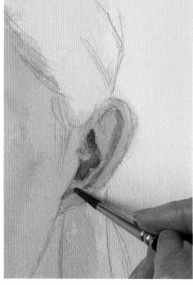

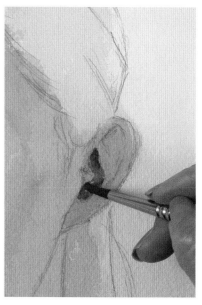

1•2 Add redness to the base color of the ears. After this has dried, apply the shadow color (Crimson Lake + Ultramarine Light + Burnt Umber) in the areas that should be darkest.

3 Before the shadow color has dried, apply Cadmium Red Deep + Ultramarine Light, and blend.

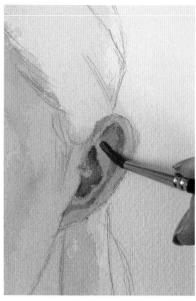

4•5 Add more shadows.

6 Add shading to the lighter middle part too.

Hint You can depict the complicated shape of the ear by installing shadows.

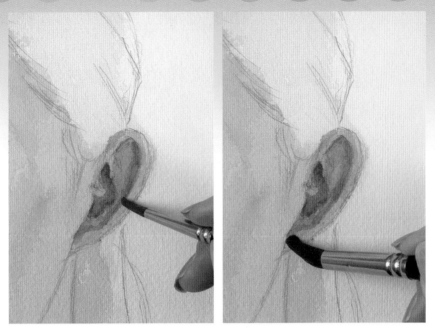

7 If the rim of the ear is too light, apply some additional shadow color.

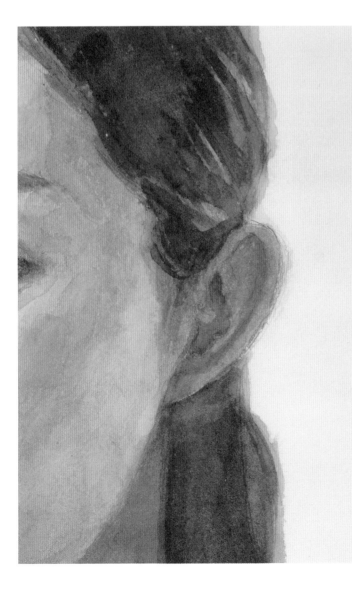

The entire painting

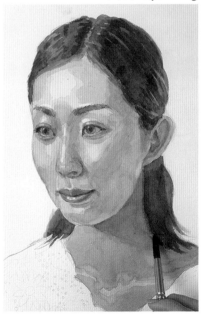

Consider the contrast of the hair and the skin near the ear as tone down the entire ear even more to finish.

Place shadows skillfully when depicting the nose

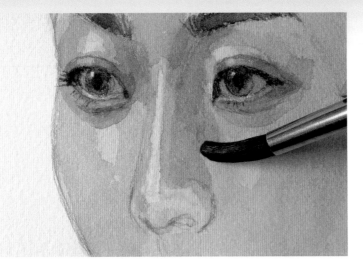

1 Start with the area adjacent to the highlight on the bridge of the nose. Apply some bluish-gray (Crimson Lake [a lesser amount] + Cobalt Blue [a larger amount] + Yellow Ochre [a lesser amount]) on the side of the nose, and blend.

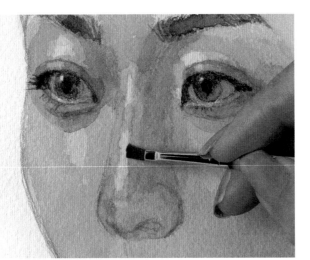

2 Use a moistened flat brush to apply a blue wash to the highlight on the bridge of the nose.

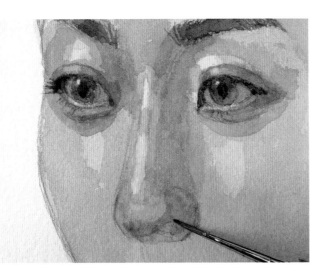

3 Paint shadows under the nose.

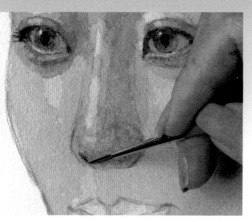

4 Paint in the shadows of the nostrils (dilute Burnt Umber + Ultramarine Light).

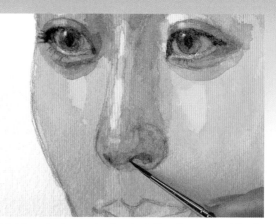

5 Paint in a shadow-color line to define the upper side of the nostrils.

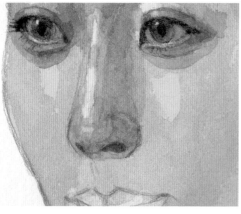

6 Spread that shadow color downward to fill the nostrils.

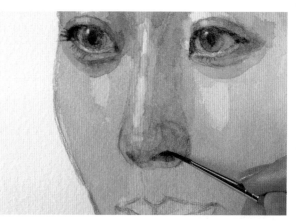

7 Layer on more shadow color into the deep dark recesses of the nostrils.

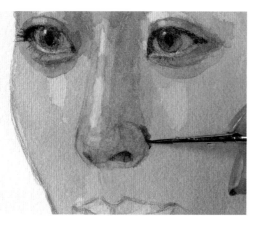

8 Paint the shadow from the side of the nose to the base.

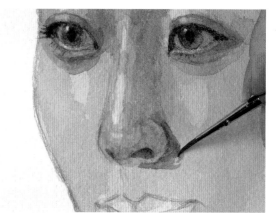

9 Expand the shading at the lower portion of the nose.

Hint **Use a thin no. 1 brush to paint the details.**

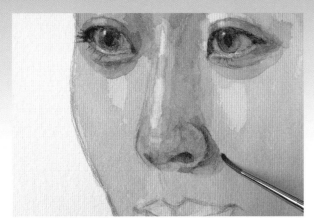

10 Blend the edges of the shadows.

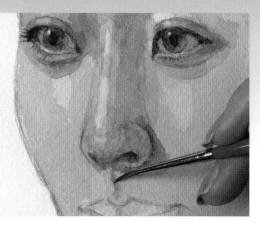

11 Pay attention to the positions of the shadows as you paint in the indentation below the nose (philtrum) from the center of the base of the nose to the top lip.

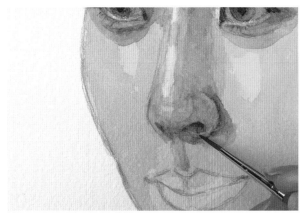

12 If the edges of the nostril are too light, apply some shadow color.

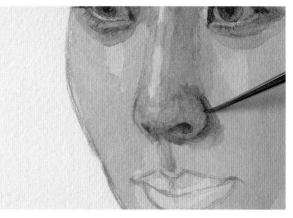

13 Add shadow to the side of the nose again.

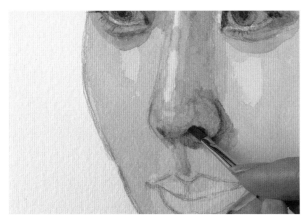

14 The top edge of the nostril is lighter because of reflected light. Use a moistened stiff, flat brush to soften the paint in this area.

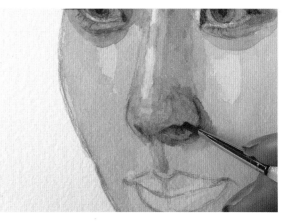

15 Use a piece of tissue paper to remove a little paint, lightening the moistened area.

 Hint **When you've achieved the tone you want, immediately remove any extraneous paint.**

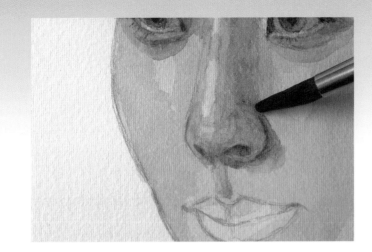

16 Apply more shadow color to the side of the nose to further emphasize its three-dimensionality.

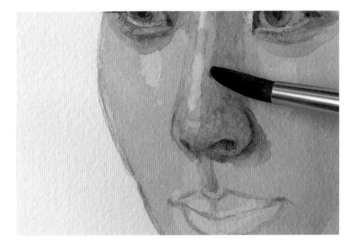

 Hint Lay your brush on its side to soften the edges.

17

The entire painting

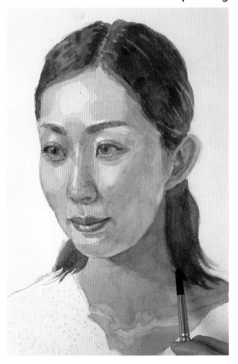

Completed!

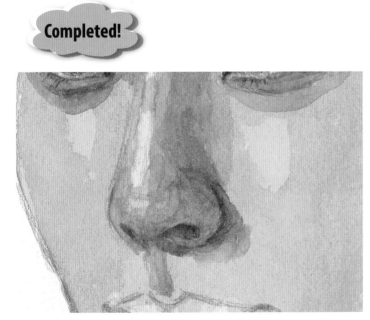

By applying and finessing the shadow colors skillfully, you can depict a realistic three-dimensional nose.

Paint the mouth and lips, and the shadows around them

The depiction of the mouth is very important. In particular, the skillful application of shadows to the lips can make the expression look realistic. Paint this area with care.

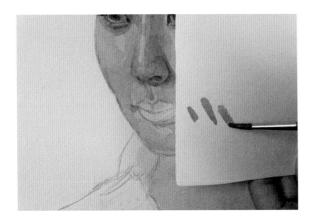

1 Paint some test swatches on a separate piece of paper to zero in on the color for the lips. The base color is Cadmium Red Deep + Crimson Lake.

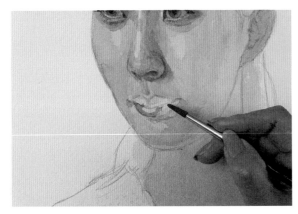

2 Leave the light areas unpainted.

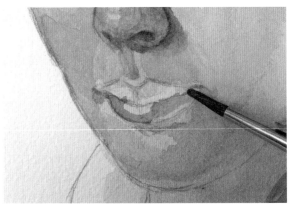

3 The lower lip is a little lighter because the light hits it.

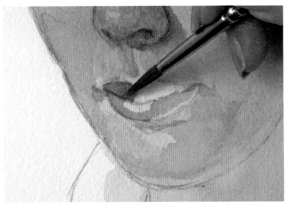

4 The upper lips are little darker.

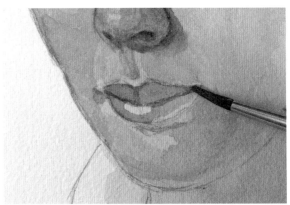

5

Hint

Carefully indicate the shape of the bow of the lips.

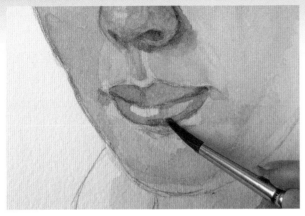

6 Layer on the base color in the darker areas.

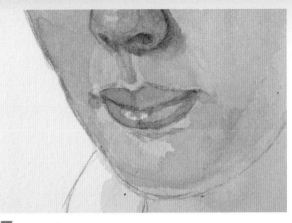

7 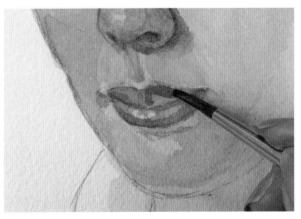 **Hint** **The unpainted areas become the highlights.**

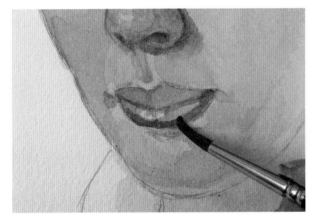

8 Layer on the base color to deepen the color.

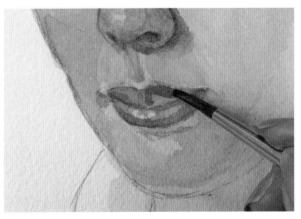

9 Make the upper lip a little darker.

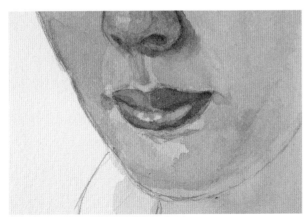

10 The lips are gradually looking more three-dimensional.

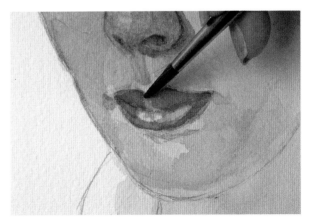

11 Paint on a combination of the base color + Ultramarine Light in the shadow areas of the upper lips and the corners of the mouth.

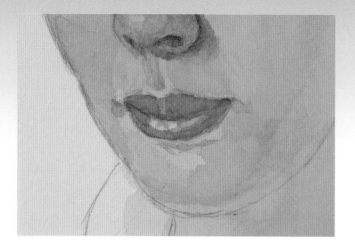

12 The base is complete.

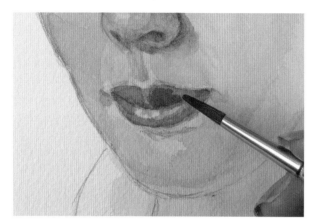

13 Because the right side here is in shadow, add more Ultramarine Light to the base color to make a deeper version of the previous shadow color, and paint this on.

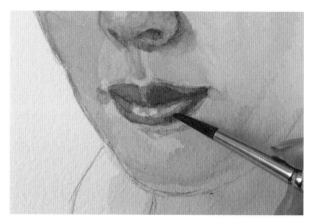

14 Layer on this same color on the lower part of the lower lip.

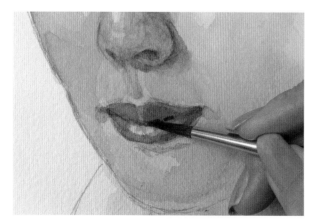

15 Paint a line from the center of the mouth toward the corners between the lips.

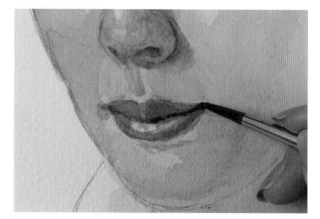

16 Layer more paint in the corners of the mouth.

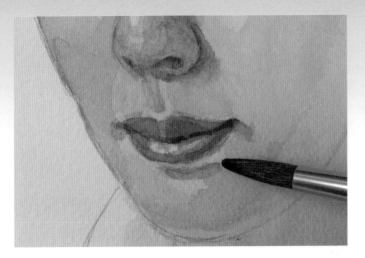

17 Add shadows around the mouth (around the corners of the mouth and under the lips).

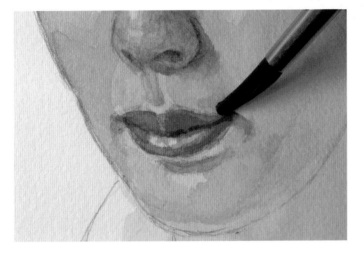

18 Add light shading to the relatively dark part of the upper lip too.

The entire painting

Completed!

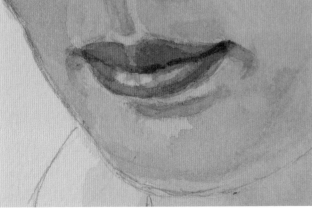

If you pay close attention to the shape and the shadows, you can paint realistic lips.

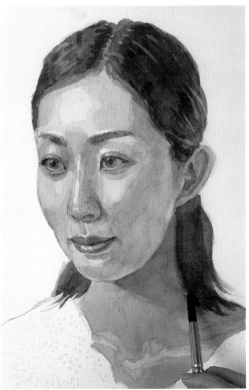

Sidebar

Common mistakes made when sketching the subject

People usually face the person they're speaking to. Because we have the image of the "front-on face" burned into our minds, it's easy to mistakenly draw a front view face even when the face is oriented diagonally.

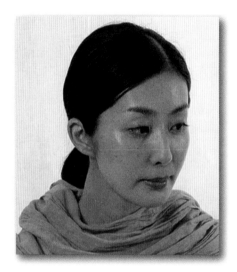

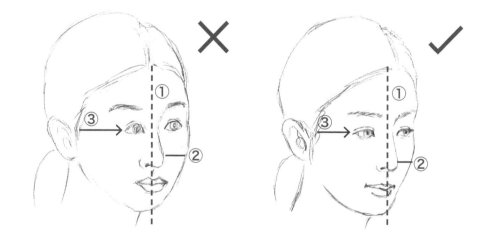

Three reasons why the drawing on the left is incorrect:
① The front center line of the face is incorrectly placed.
② The distance between the nose and the side of the face is inaccurate.
③ The distance between the outer end of the eye and the hair on the side of the face is inaccurate.

The eyes, lips and eyebrows are drawn as if they were facing the front in other ways in this example too. Be sure to observe the model's face well when you are drawing it.

Chapter 4

Clothing and Backgrounds

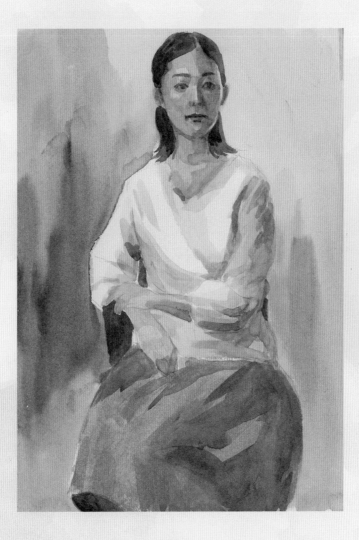

In this chapter, I will show you some tips for painting clothes and backgrounds that enhance the look of the main figure, as well as how to paint backlit areas.

How to Depict Clothing

Clothing is an important element of a figure painting. However, it is particularly challenging to depict the intricate patterns or texture of clothing with watercolors. Here, I will show you two techniques for depicting clothing.

> **An example using a draft drawing**

A draft drawing is a detailed drawing added to the painting that depicts the outlines and small details of the subject. It allows you to paint the shapes freely with the brush.

Lesson 38	Add the shadows while leaving any areas that look white unpainted

A photo of the clothing we are attempting to paint

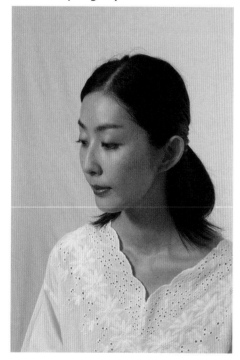

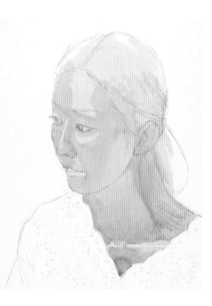

1 The clothing has been left unpainted.

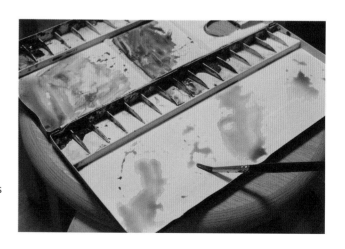

2 Make up 4 variations of the skin colors that shows through the fabric in advance.

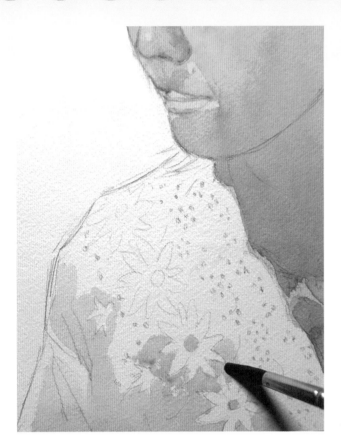

3 Leaving the lightest parts of the fabric untouched, paint in the parts where you can see the skin through the fabric.

4 The way the skin shows through varies depending on how the fabric is draped, so change the shadow colors used as you paint around the white parts.

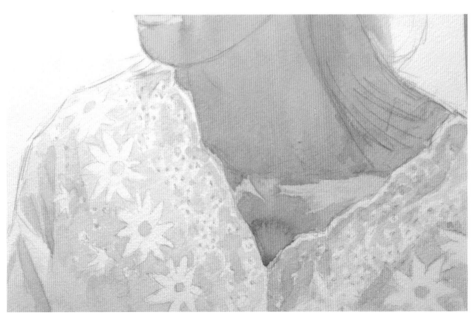

Hint By changing the shadow colors, you can expressively depict the parts where the skin tone shows through the fabric.

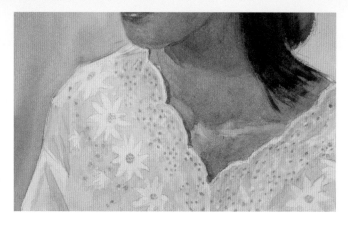

5 Indicate the small details as you add shadows to the whole top to depict three-dimensionality.

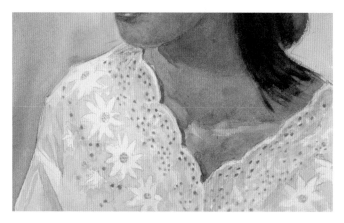

6 Add the shadows to the darker areas to finish.

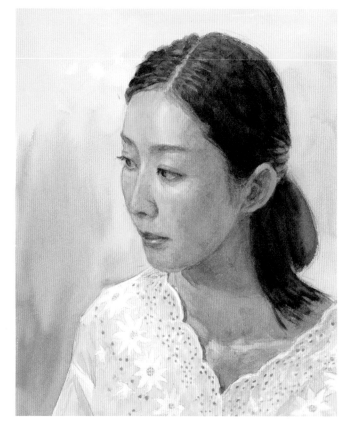

Fine-tune the whole area to tie together the entire piece of clothing to finish.

Size: 19.7 × 14.6 in (50 × 37 cm)
Paper: Arches

An example using the masking method

Masking is a method used where parts of a painting are covered with something such as masking fluid or another piece of paper to avoid having color applied to the protected areas. With this method, it's not necessary to delicately work around small unpainted areas, because you can apply paint speedily over the protected areas of detail.

Lesson 39 · Depict lights and darks over masked areas

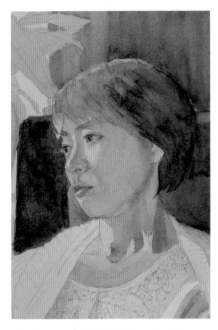

1 Be aware of the light coming from the upper diagonal corner as you paint the clothing.

2 Although this is white clothing, it is partially in shadow, so paint this area with a light gray before applying masking fluid to it. Masking fluid is best applied with the paper laid flat to avoid any drips.

3 Once the masking fluid has dried completely, start depicting the light and dark areas of the fabric on top of it.

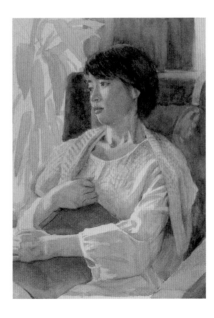

4 Paint in the creases on the fabric and its light and dark areas, and check to ensure that the whole composition is balanced.

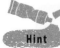

Hint

There's no need to leave any details unpainted.

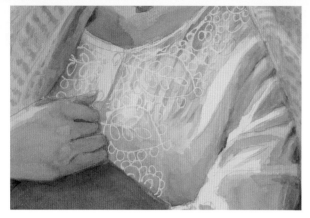

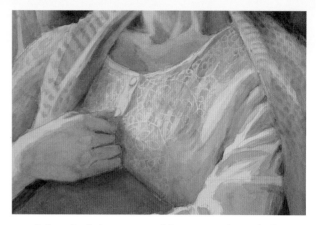

5 After the paint has dried completely, peel off the masking fluid.

6 Adjust the lightest parts of the previously masked areas, and add shadows to the hands and the fabric to depict three-dimensionality.

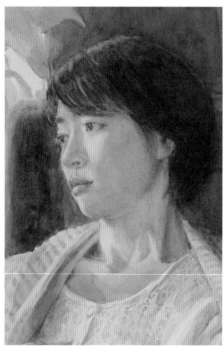

7 Shadows have been added to the clothing all over.

Completed!

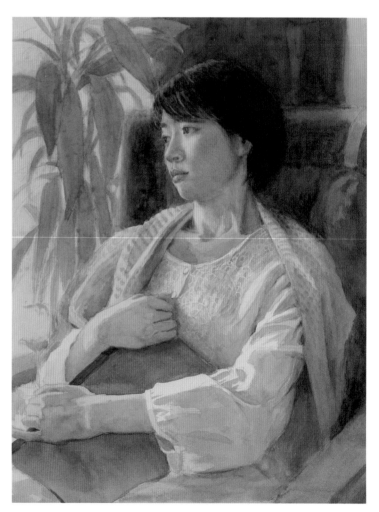

Fine-tune the whole area to tie together the entire piece of clothing to finish.

Size: 28.7 × 21.5 in (73 × 54.5 cm)
Paper: Arches

Lesson 40 Paint patterns from light to dark

Reference photo of the clothing to be painted

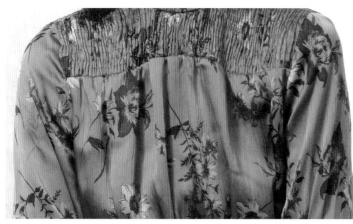
A floral-patterned dress

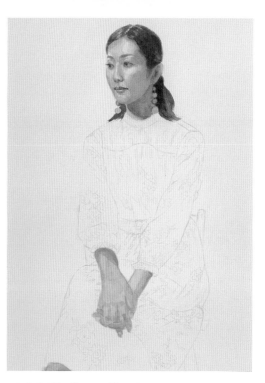

1 Paint the face and hands.

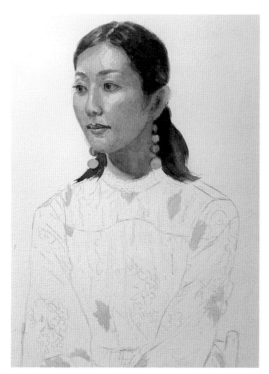

2 Begin working on the clothing by painting in the lightest parts of the floral pattern.

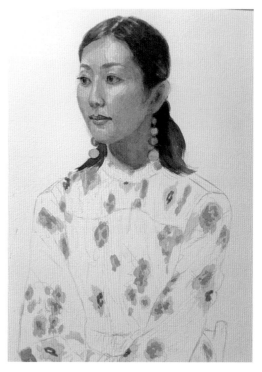

3 Paint in the somewhat darker parts of the pattern.

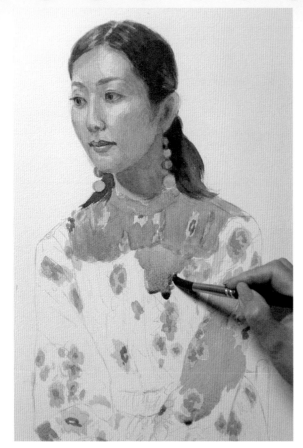

4 Paint the base color of the fabric.

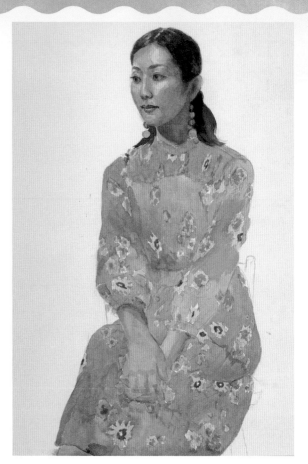

5 The base color is complete.

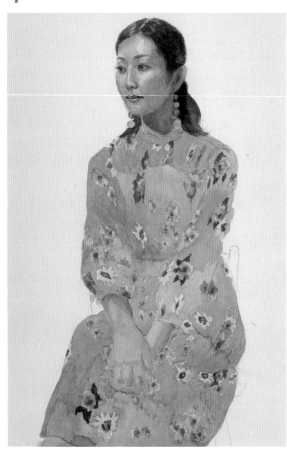

6 Add the darkest parts of the floral pattern.

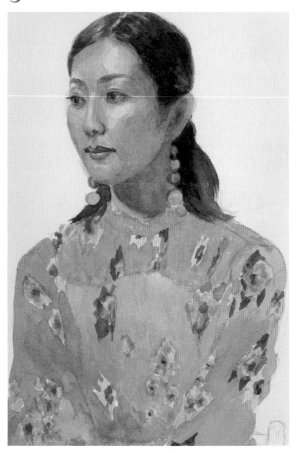

7 Evaluate the parts you have painted in so far.

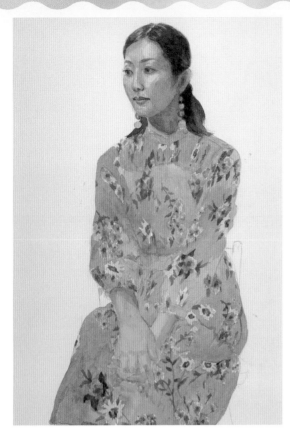

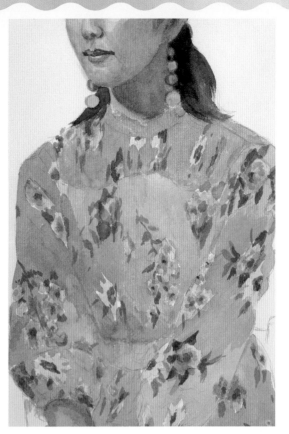

8 Paint in the leaves and stems of the floral pattern.

9 Check the pattern you've painted for completeness.

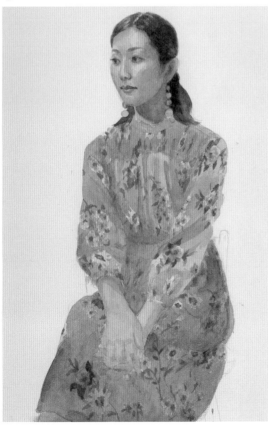

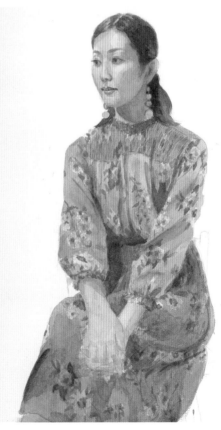

10 Add shading to the folds and creases all over the dress to bring the figure into the round.

By adding the creases and wrinkles, you will increase the subject's three-dimensionality.

Hint

11 Deepen the contrasting shadows.

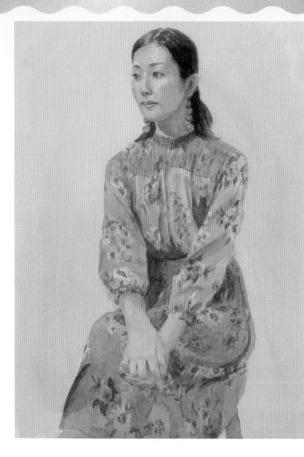

12 Paint in the background color.

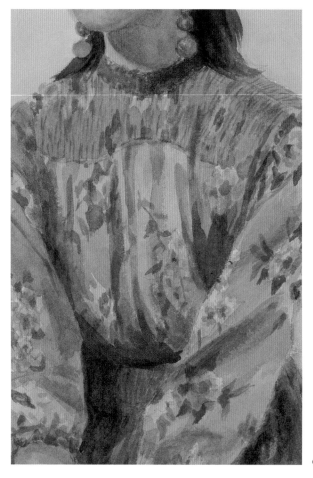

13 Apply Crimson Lake to the dark parts to make the fabric appear more three-dimensional.

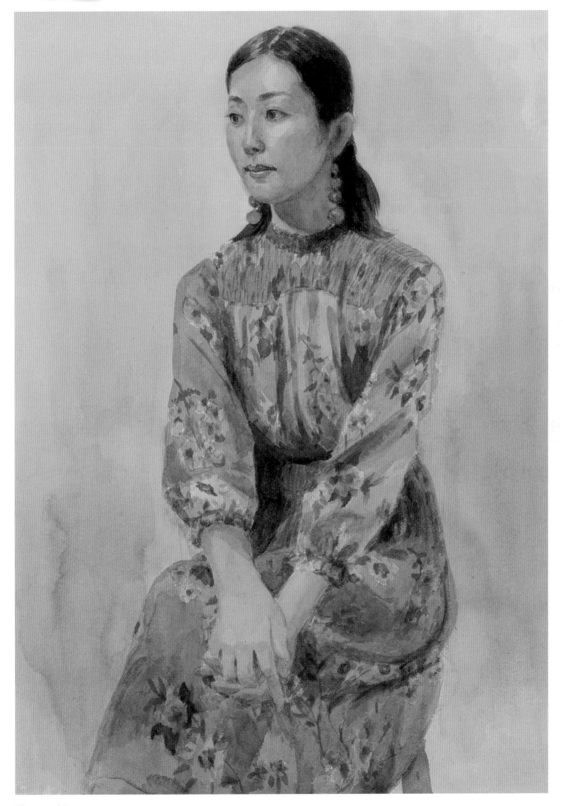

Flowered Dress
Size: 22.4 × 16.5 in (57 × 42 cm)
Paper: White Watson

How to Depict the Background

In this section, I will introduce you to some of the primary techniques for depicting the background, such as ways to show depth and distance and how to paint the background when the subject is backlit.

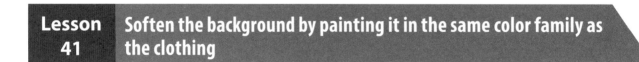

Lesson 41 — Soften the background by painting it in the same color family as the clothing

By using the color of the clothing in the background, you will lend a calm, gentle impression to the painting.

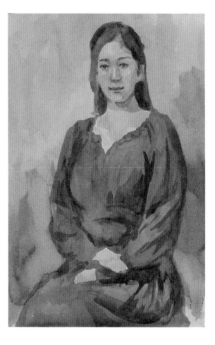

Lesson 42 — Strengthen the background by painting it in colors that are complementary to the clothing

By using a color complementary to the clothing (a color appearing on the opposite side of the color wheel) in the background, you can make the clothing really stand out and make a bold impression. In addition, by using the background color as the shadow color in the clothing, the overall effect will be natural and familiar.

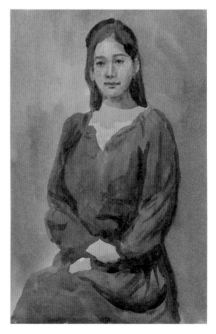

Lesson 43 Use contrast to give a sense of depth to a scene without depicting a realistic background

Use contrast to indicate the depth of the space. In order to enhance the figure itself, it's best not to use bold colors in the background.

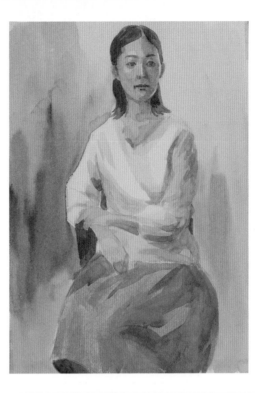

Lesson 44 Be mindful of the contrast and saturation when depicting objects in the background

Even when you are depicting a detailed background, don't use strongly contrasting lights and darks or intense colors, and be sure what you depict there enhances the figure. In addition, don't paint too much detail into the background—it shouldn't compete with the foreground.

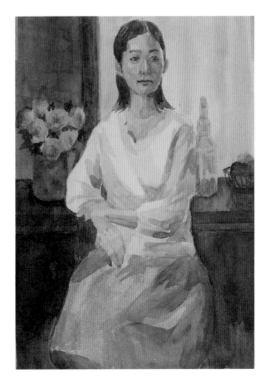

Lesson 45 — When the subject is lit obliquely or from the front, make the background dark

When the light source is from the side or from the front, you can see the distinct colors of the face and clothing well, and you can understand the subject's three-dimensionality through the presence of shadows. In order to establish the subject's position in space, darken the background. Selectively leave the light areas in the background to suit the composition.

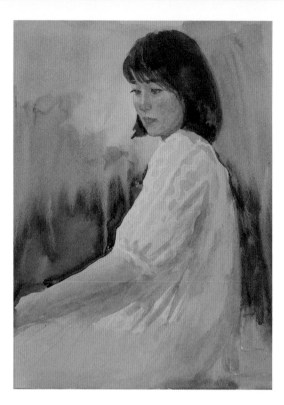

Lesson 46 — When the subject is backlit, lighten the background to emphasize the subject's silhouette

By making the background light you can emphasize the silhouette of the subject. Because the details of the face and clothing lose contrast and become ambiguous, it's important not to paint in too many details.

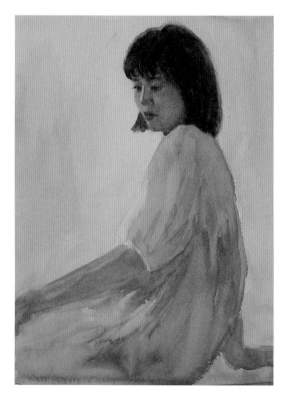

Lesson 47 — When the figure is isolated, add a background from your imagination

When there are no hints as to what should be in the background, try adding imagery from your imagination. In this piece, I've placed the figure in an imagined outdoor setting.

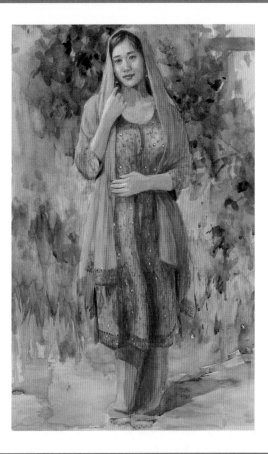

Lesson 48 — When you want to focus attention on the figure, keep the background simple

In this case I wanted the viewer to focus on the figure in the painting, so I made the background simple. Light gray tones provide hints about the depth of space being depicted.

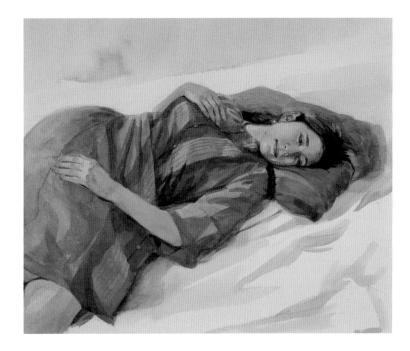

Sidebar

Strategies for background painting

One of the challenges presented by figure painting is how to handle the background. When the items in the room pair well with the person being depicted, you can paint them as-is (see page 89)—or you can rearrange them to suit the composition.

However, when the background elements do not improve the composition, be flexible in your thinking. One solution is to think of the background in a fashion sense, borrowing the colors from the model's clothing.

In addition, when you are painting, you are observing details closely, so you don't see the whole image objectively. After studying the subject really closely, try flipping your painting over 180 degrees or viewing it from afar to check if the whole composition is harmonious.

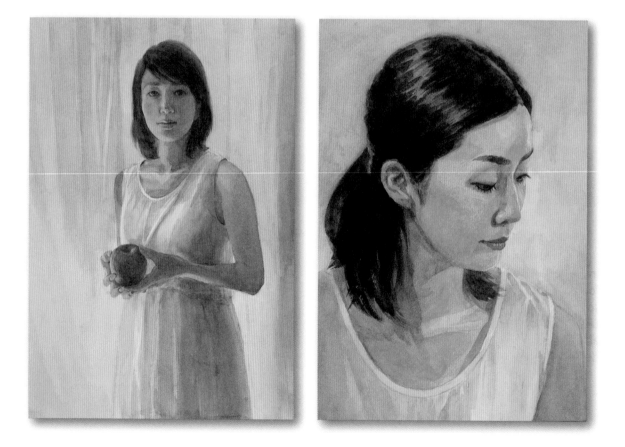

Chapter 5

Reviewing the Process—From Sketch to Finished Painting

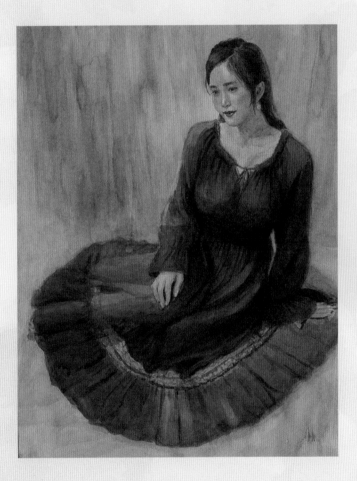

In this chapter, I will break down the whole process of creating a watercolor figure painting, using two works as case studies. Refer to all of the tips provided up to this point as you explore these examples.

Case Study: The Creation of the Work "Flower Petals"

<div style="border:1px solid; border-radius:20px; display:inline-block">

Depicting the head

</div>

Comments about the work

When viewed from above, the skirt of this sideways sitting pose looked like the beautiful petals of a flower.

I focused on the shape of the body underneath the clothing, and the soft flow of the fabric, as I painted this.

The tools I used
- Kolinsky brushes no. 10, no. 14
- Wide *nihonga* (Japanese painting) brush—approximately ¾-in (2-cm) wide
- Holbein Para Resable brushes (synthetic/natural hair blend) no. 6 and no. 10
- Thin brush no. 1
- Porcelain palette

Model reference photo

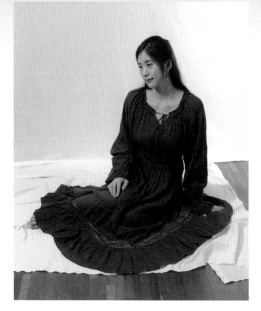

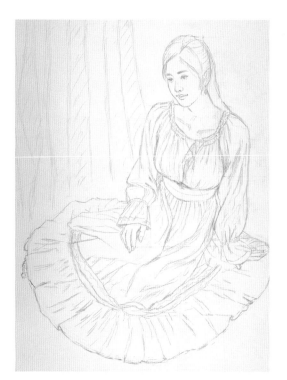

1 The sketch is complete.

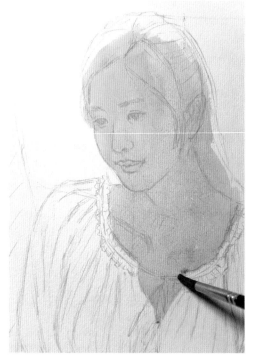

2 Paint a flat layer of the base color of the skin (Cadmium Red Deep + Cadmium Yellow Light) from the top to the bottom.

See Lessons 22 and 28

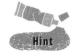

Hint Paint on the skin color over the entire subject, excluding the clothes and background.

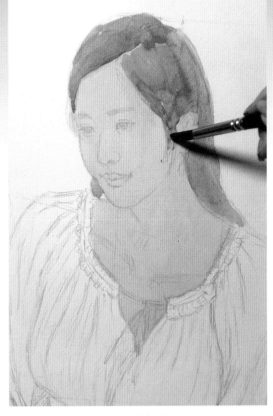

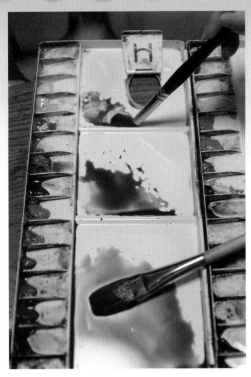

3 Mix three colors to use as the base for the hair (using Burnt Sienna as the main color and adding Ultramarine Light, Cadmium Red Light, Burnt Umber and so on).

4 Paint the base colors of the hair.

See Lesson 30

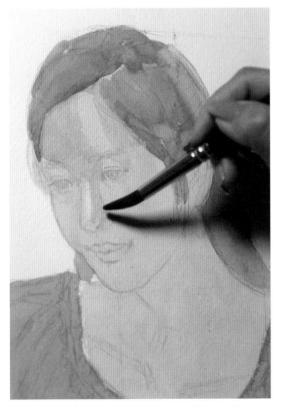

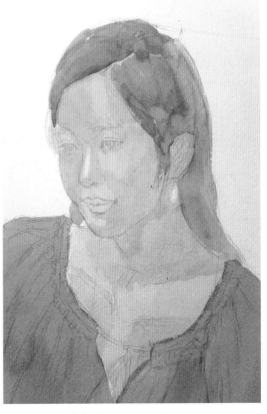

5 Deepen the skin color using a medium dark color. (See page 98 for information on the process of painting the clothing.)

6 The overall skin base is complete.

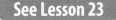
See Lesson 23

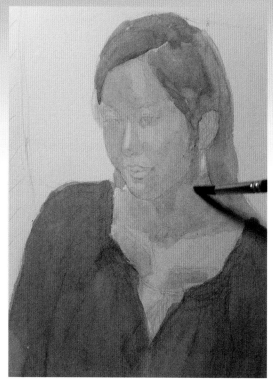

7 Paint in Cobalt Blue as a shadow on the neck.

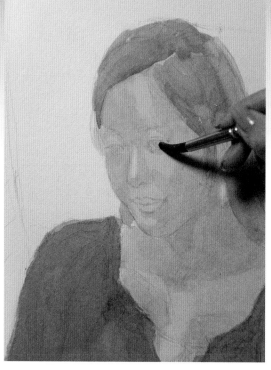

8 Paint a light layer of Cobalt Blue under the eyes too.

See Lessons 27 and 32

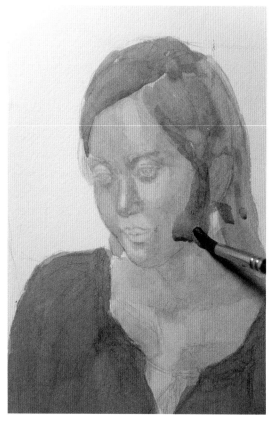

9 Paint in the shadow color (Crimson Lake + Cobalt Blue + Yellow Ochre) on the side of the face.

See Lessons 27 and 29

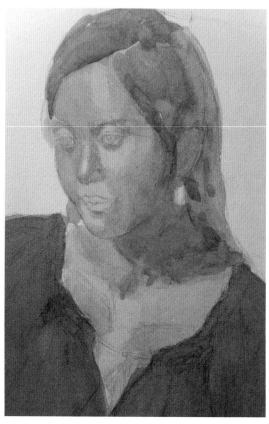

10 Use the same shadow color to paint in the shadow created by the head on the neck and shoulder.

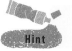

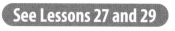
Hint

Use a variety of colors in the shadow parts too.

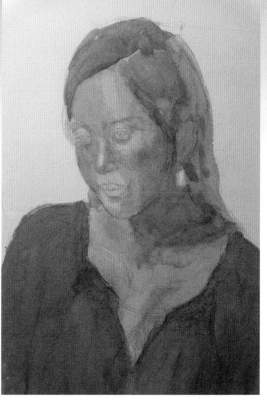

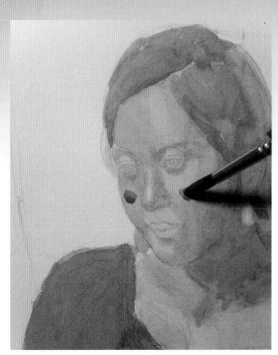

11 Place Cadmium Deep on the cheeks.

12 The three-dimensionality of the cheeks is emerging.

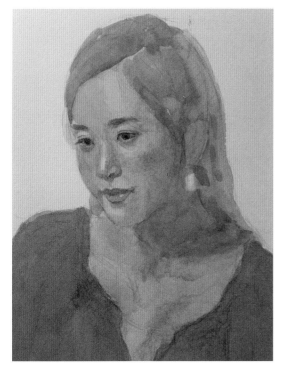

13 Paint in the base colors for the eyebrows, eyes, nose and mouth.
- For the eyebrows, use Burnt Umber + Ultramarine Light
- For the eyes, use Ivory Black + Burnt Umber + Ultramarine Light + Cobalt Blue + Crimson Lake
- For the nose, use Cadmium Red Deep + Crimson Lake + Cobalt Blue + Yellow Ochre + Burnt Umber
- For the mouth, use Cadmium Red Deep + Crimson Lake + Burnt Umber + Ultramarine Light

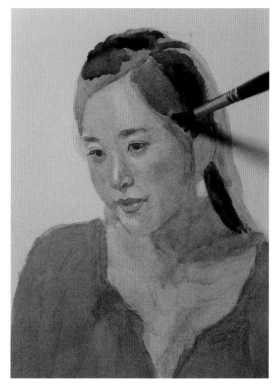

14 Paint Burnt Umber + Ultramarine Light into the dark parts. While the paint is still wet, apply Burnt Umber on its own to the light parts.

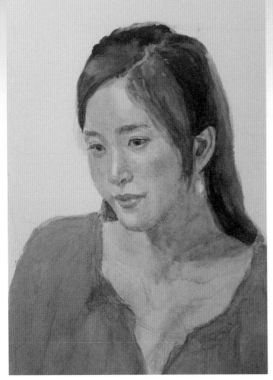

15 Paint in the nuances of the hair.

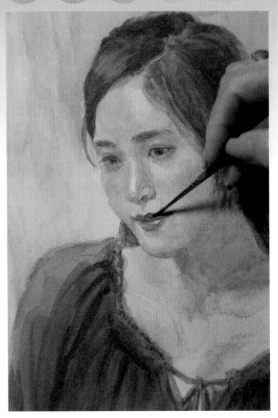

16 Paint the lips.

See Lessons 31 and 37

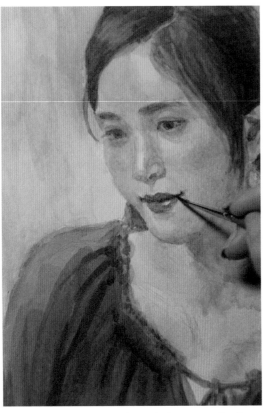

17 Paint in the line where the lips meet clearly.

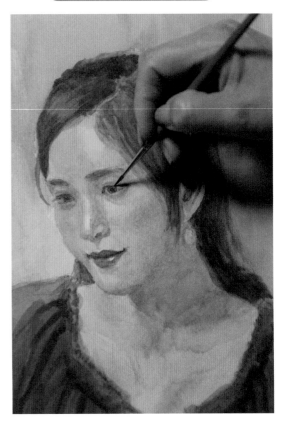

18 Paint in the line of the upper eyelids with a thin brush.

See Lesson 32

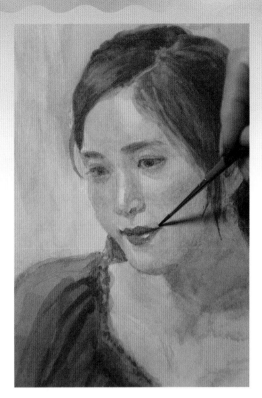

19 End by adding detailed shadows, and adding more nuance to the hair.

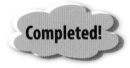

1 Determine the color of the clothing and mix the colors. Crimson Lake (a large amount) + Burnt Umber (a lesser amount) + Ultramarine Light (a large amount).

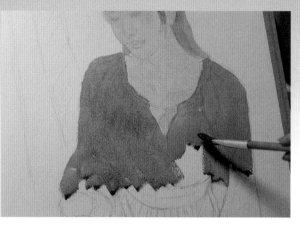

2 Lay down a flat layer of color from top to bottom.

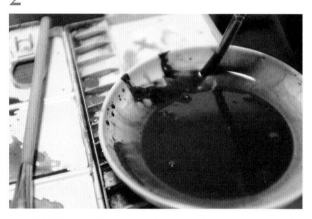

4 Add Ultramarine Light or Hooker's Green to the mixed color above to make a dark red. (Because a large amount of paint is needed, make it in quantity in a shallow bowl.)

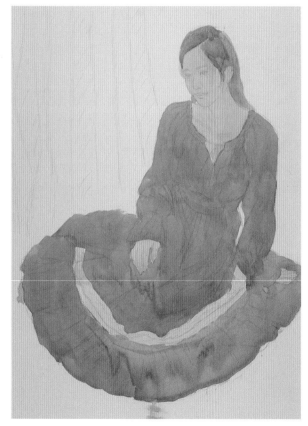

3 The flat layer of color for the clothing has been painted in.

 Use a flat brush and paint in broad strokes.

Hint

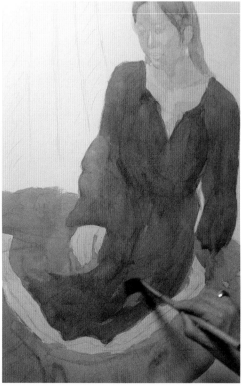

5 Avoid the light parts and layer on the dark color.

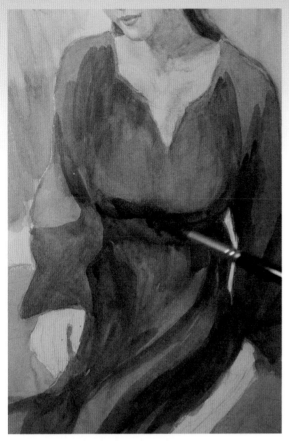

6 Using less-diluted paint, add color to the darker areas.

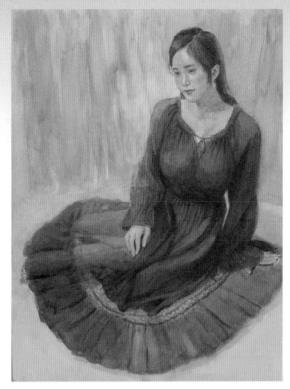

7 The overall light and dark areas of the clothing have been painted in.

Completed!

8 Use Ultramarine Light on its own to paint shadows into the darkest areas.

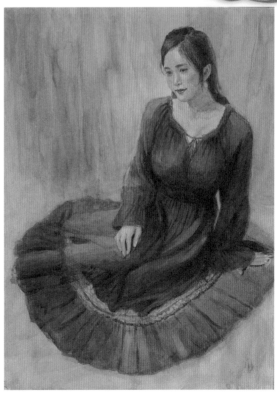

P20 (28.6 × 20.9 in / 72.7 × 53 cm)
Paper: White Watson

Case Study: The Creation of the Work "Backlit by the Window Side"

Comments about the work

This is a painting of a woman holding an apple as a symbol of life. The soft light coming in from the window is symbolic of hope.

I really strove to depict the subtle lights and darks of the face and clothing, even with the shadows cast by the backlighting.

The tools I used
- Kolinsky brushes no. 10 and no. 14
- Wide *nihonga* (Japanese painting) brush—approximately ¾-in (2-cm) wide
- Holbein Para Resable brush (synthetic/natural hair blend) no. 6

1 Block in a light sketch.

2 Using a measuring stick, measure the head and put in the supplementary lines to aid the composition of the drawing.

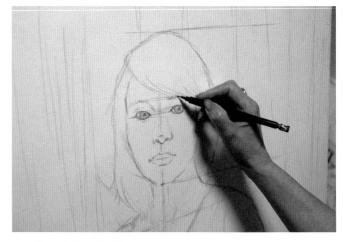

3 Draw in the details.

See Lessons 9 and 16

100

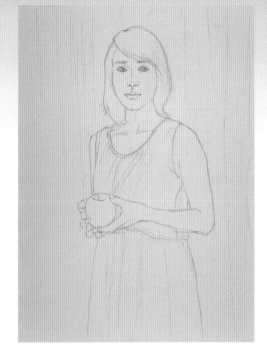

4 The sketch is complete. Erase the extraneous pencil lines.

5 Mix Cadmium Red Deep + Cadmium Yellow Light to create the skin color.

See Lesson 22

6 Check the skin color on a separate piece of paper.

Hint **Check the colors before applying them to your painting.**

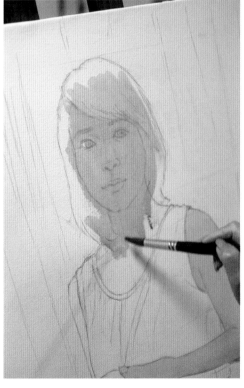

7 Lay down a flat layer of paint over the head and skin using the Kolinsky no. 14 brush.

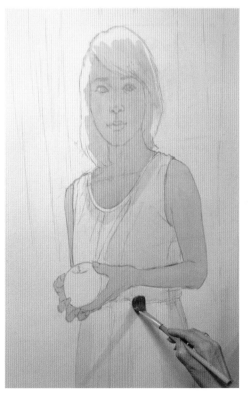

8 Use the wide 0.8-in (2-cm) Japanese painting brush to paint the white dress gray, leaving the lighter parts unpainted. (Use a mix of Crimson Lake + Manganese Blue Nova + Raw Sienna.)

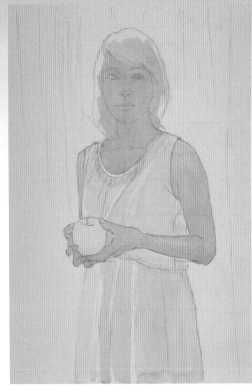

9 A light gray has been applied to the dress.

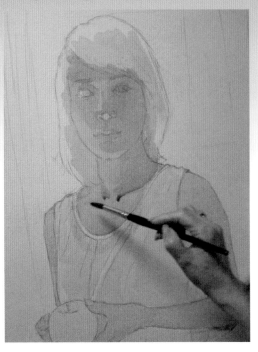

10 Leaving the bridge of the nose, the tip of the nose and so on unpainted, layer on the shadows of the face (Crimson Lake + Cobalt Blue + Yellow Ochre).

 Hint **Be careful to avoid the areas you need to keep unpainted as you work.**

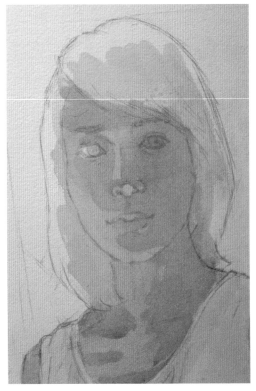

11 The base of the skin is applied.

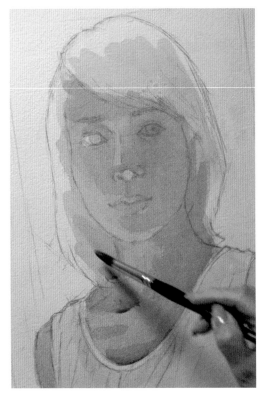

12 Paint Manganese Blue Nova into the shadowy areas (skin, hair).

 See Lesson 23

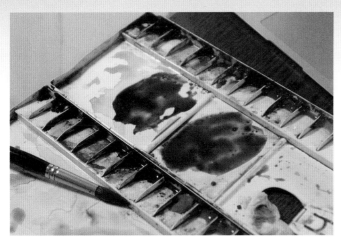

13 Mix up the dark shadow color (Crimson Lake [a large amount] + Cobalt Blue [a large amount] + Yellow Ochre [a medium amount]).

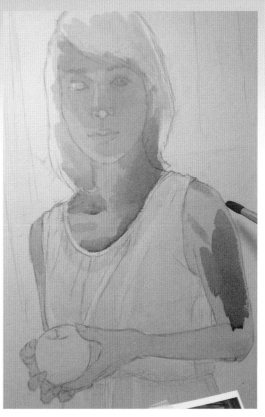

14 Leave the light areas of the shoulders unpainted as you layer on the paint.

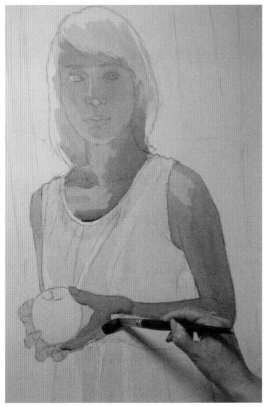

15 Spread the paint to the tips of the fingers.

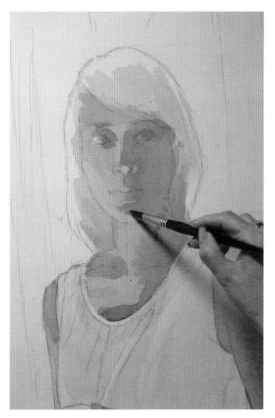

16 Dilute this color somewhat and apply it to the darker areas of the face.

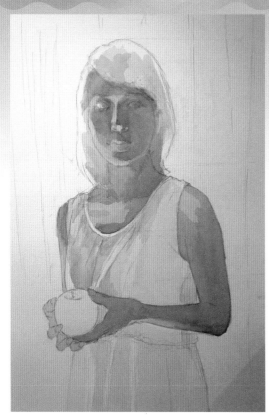

17 The effect of the backlighting has been painted in, centered on the skin.

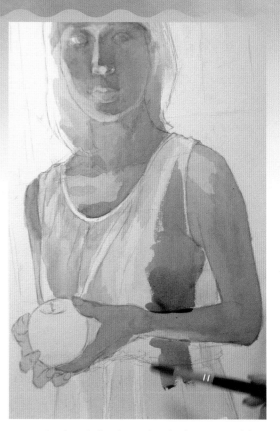

18 Apply a dark color in the shadow areas of the clothing (Crimson Lake [a large amount] + Ultramarine Light [a large amount] + Yellow Ochre [a lesser amount]).

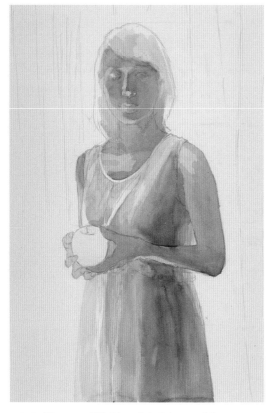

19 The overall light and dark tones of the clothing have been painted in.

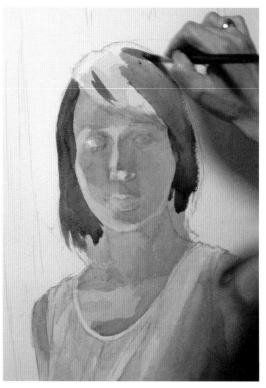

20 Color the hair (Crimson Lake + Ultramarine Light + Burnt Umber).

See Lesson 30

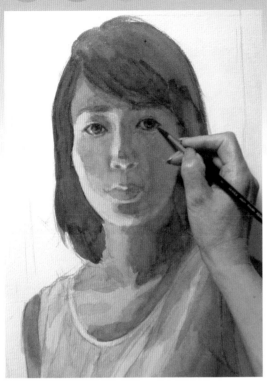

21 Paint in the eyes, nose and mouth.

See Lessons 32, 36 and 37

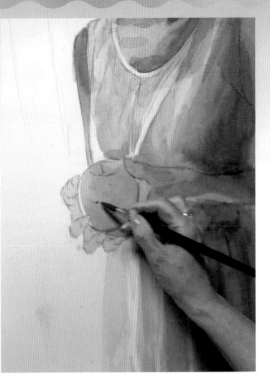

22 Paint the primary color of the apple (Cadmium Red Light).

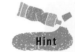 **Hint** **A more attractive color can be achieved by mixing the colors on the paper while the paint is still wet.**

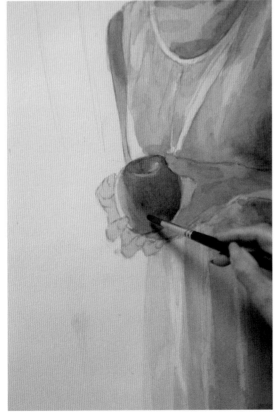

23 Apply Crimson Lake before the first color you put down (Cadmium Red Light) has dried.

24 Apply Sap Green before the paint has dried.

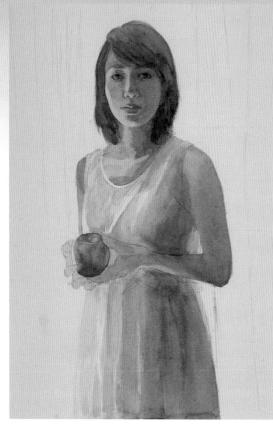

25 The overall light and dark areas have been painted.

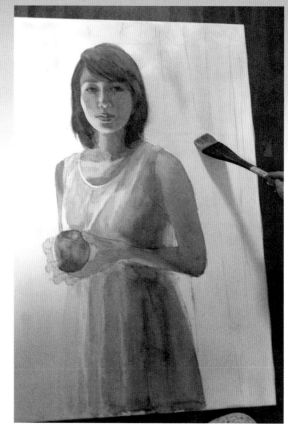

26 Add the background.

See Lessons 41, 43 and 46

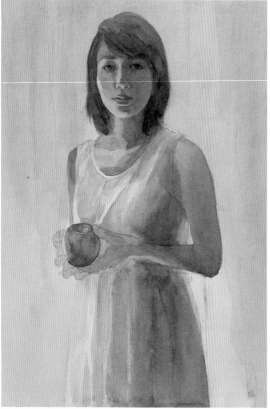

27 Add the dark colors to the background.

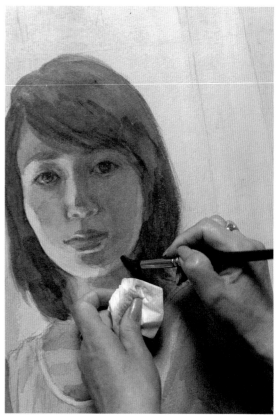

28 In order to depict the reflected light coming from behind, pull a little paint off the edge of the cheek with a wet brush and a tissue, and apply some Manganese Blue Nova.

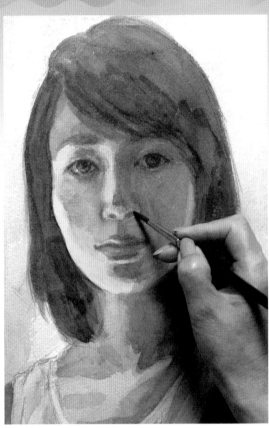

29 Add the shadows of the face.

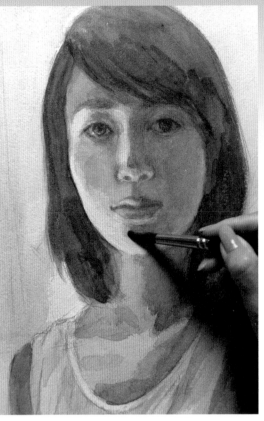

30 Blend any transitions that are too sharply defined.

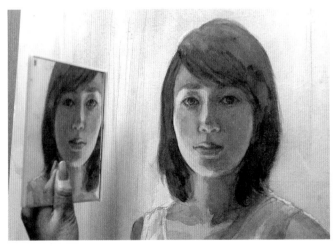

31 Check the face in the mirror to see if anything looks amiss.

When painting a figure, be sure to check it in a mirror!

Hint

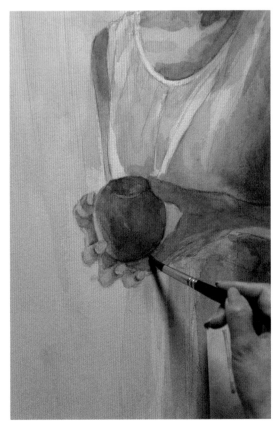

32 Layer on the first detail color of the apple, Crimson Lake.

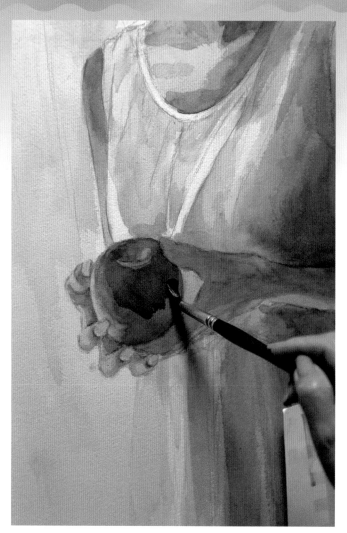

Hint Apply dark colors to a dry surface to depict shadows.

33 Apply the second detail color of the apple, Crimson Lake + Ultramarine.

34 It is backlit so it's quite dark.

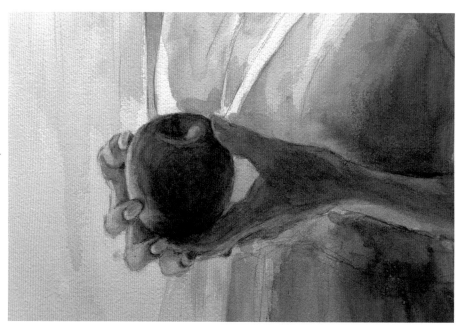

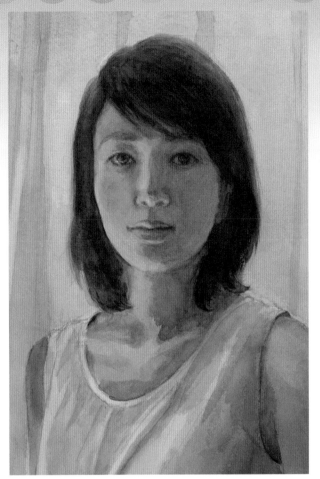

Completed!

The entire painting

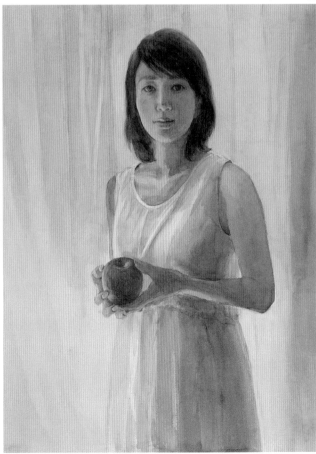

Size: 30.3 × 24.4 in (77 × 62 cm)
Paper: Arches

Bonus: Paint a Child

A child cannot hold a pose for long, so you will be painting from a photograph. Try painting the children close to you, such as your own children or grandchildren, or those of a friend.

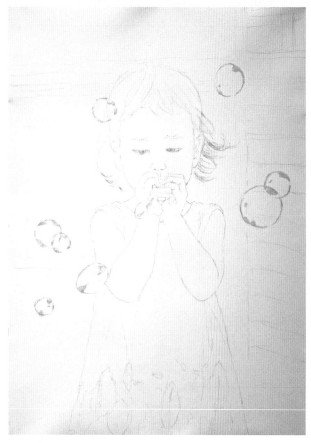

1 After the sketch is done, mask the shiny parts of the hair and the soap bubbles.

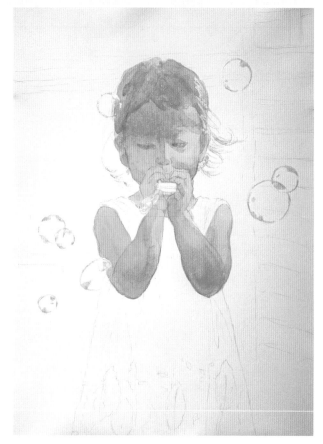

2 Paint the base color of the skin and hair. Then, add the shadows using the same color.

Depict the casual, natural appearance of children!

The smile of a child is undeniably adorable. However it is quite difficult the paint the smiling eyes, the expression of the cheeks and a mouth with visible teeth, so it's wiser to choose a photograph showing a casual expression or a nonchalant gesture. Children are cute to begin with. It's best not to strive to depict them as being cuter than they normally appear if you want to produce a natural-looking painting.

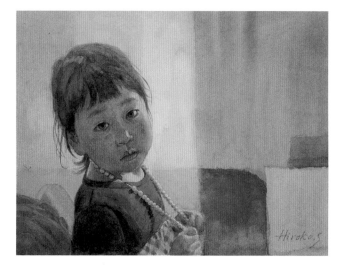

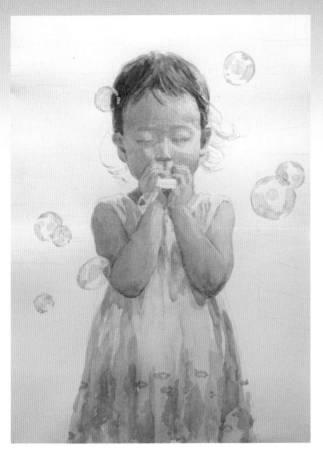

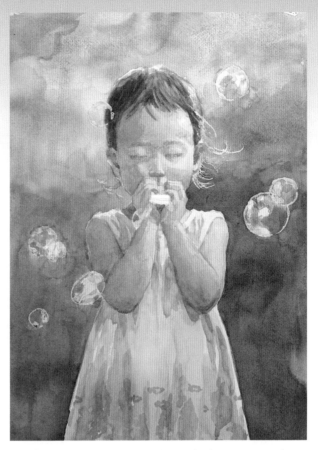

3 Layer cool colors onto the skin to strengthen the shadows. Paint in the hair and clothing.

4 Add the background over the masked areas. To gently bring forward the child and the soap bubbles, I have used a deeper tone in the background from the same color family as that of the figure.

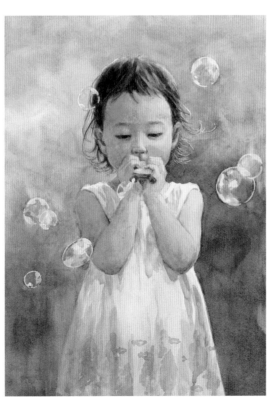

Peel off the masking fluid and add the details of the eyes, nose and so on to finish.

Size: 19.7 × 14.6 in (50 × 37 cm)
Paper: Arches

Published by Tuttle Publishing, an imprint of Periplus Editions (HK) Ltd.

www.tuttlepublishing.com

ISBN 978-0-8048-5572-3

SUISAIGA "JINBUTSU BYOSHA" JOTATSU NO KOTSU NUKUMORI TO SHITSUKAN WO REAL NI HYOGEN
Copyright © eplanning, 2019
All rights reserved
English translation rights arranged with MATES universal contents Co., Ltd. through Japan UNI Agency, Inc., Tokyo

English translation © 2022 Periplus Editions (HK) Ltd
Translated from Japanese by Makiko Itoh

Staff (Original Japanese edition)
Formatting E-Planning Co. Ltd.
Editing E-Planning Co. Ltd.
Design of the main text Hiroko Koyama
Photography Naonori Negishi

Distributed by:

North America, Latin America & Europe
Tuttle Publishing
364 Innovation Drive
North Clarendon
VT 05759-9436 U.S.A.
Tel: (802) 773-8930
Fax: (802) 773-6993
info@tuttlepublishing.com
www.tuttlepublishing.com

Asia Pacific
Berkeley Books Pte. Ltd.
3 Kallang Sector, #04-01
Singapore 349278
Tel: (65) 6741-2178
Fax: (65) 6741-2179
inquiries@periplus.com.sg
www.tuttlepublishing.com

25 24 23 22
10 9 8 7 6 5 4 3 2 1

Printed in China 2206EP

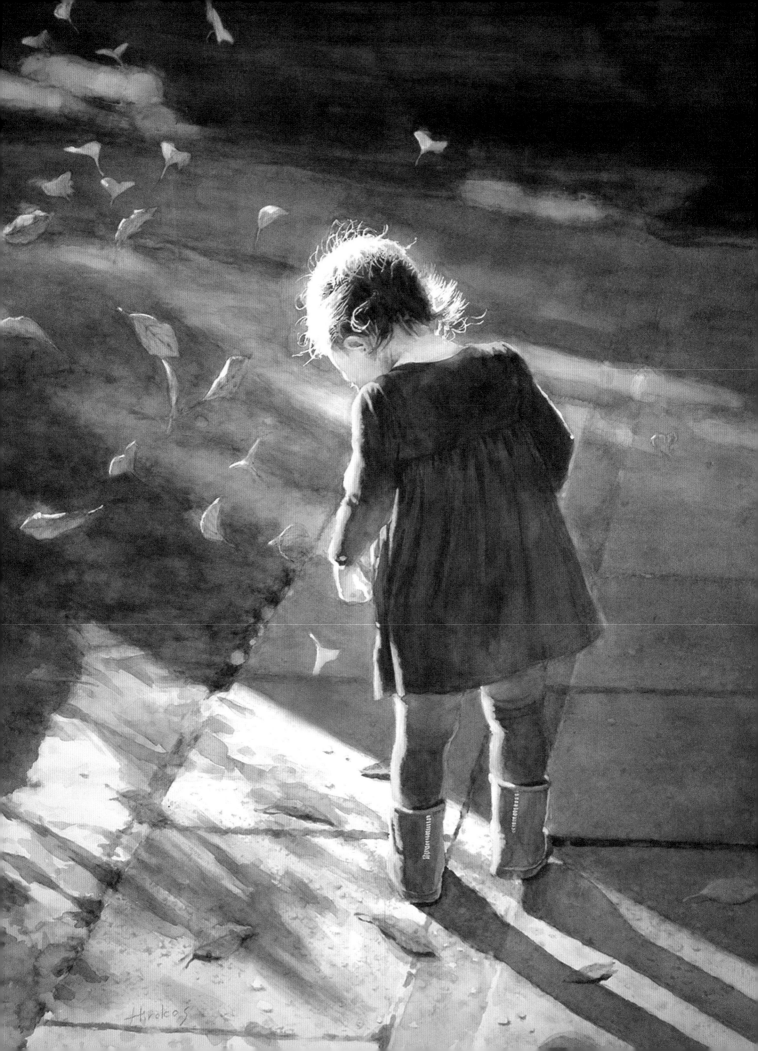